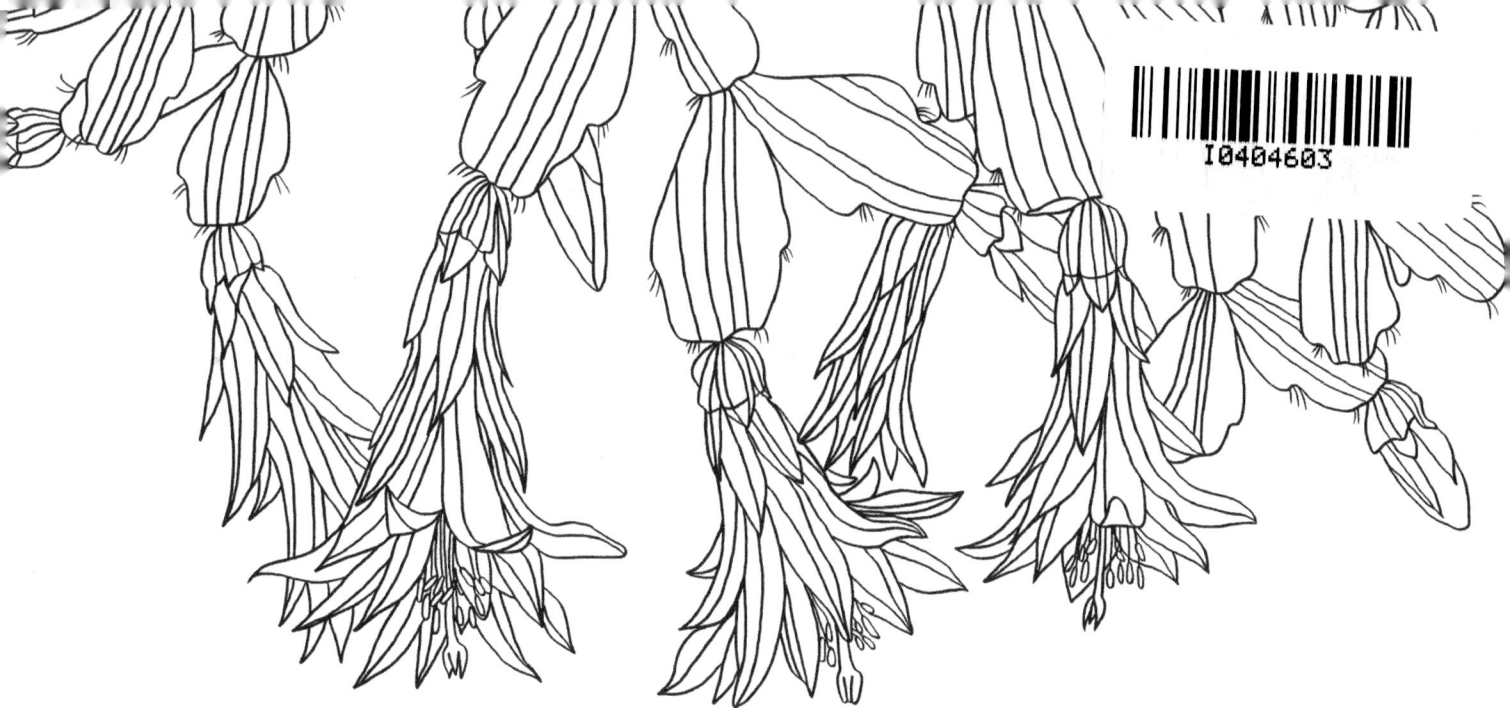

Cactus
COLORING BOOK

by Brittany Jepsen
of The House That Lars Built

All rights reserved. No part of this book may be produced or transmitted by any form or by any means, electronic, or mechanical, including photocopy, recording, or any information storage or retrieval system, without prior written consent from the author.

WWW.THEHOUSETHATLARSBUILT.COM

THE HOUSE THAT LARS BUILT
AN ARTFUL LIFE

Flowers Coloring Book
© 2016 The House That Lars Built
Springville, UT 84663

SPECIAL THANKS TO CAITLIN BOYES
who helped make this book possible

———

The pages of this book are suitable for colored pencils, markers, and a variety of other media.
To help prevent bleed-through, place a blank sheet of paper between the pages when coloring.

Happy coloring!

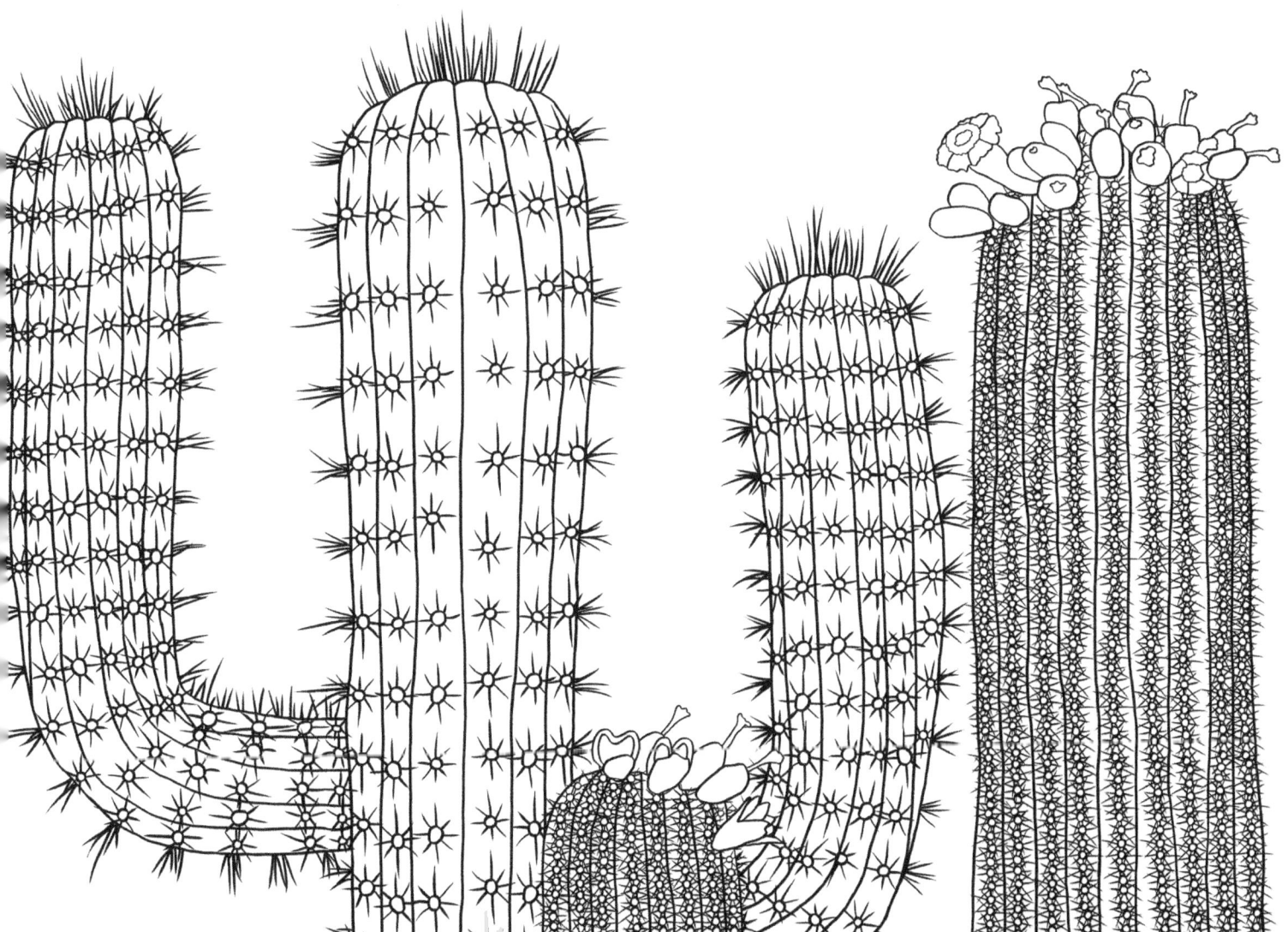

Catalogue of Cacti

Agave

Aloe

Cathedral Cactus

Climbing Cactus

Joshua Tree

Mexican Snowball

Pincushion

Prickly Pear

Rat Tail Cactus

Saguaro

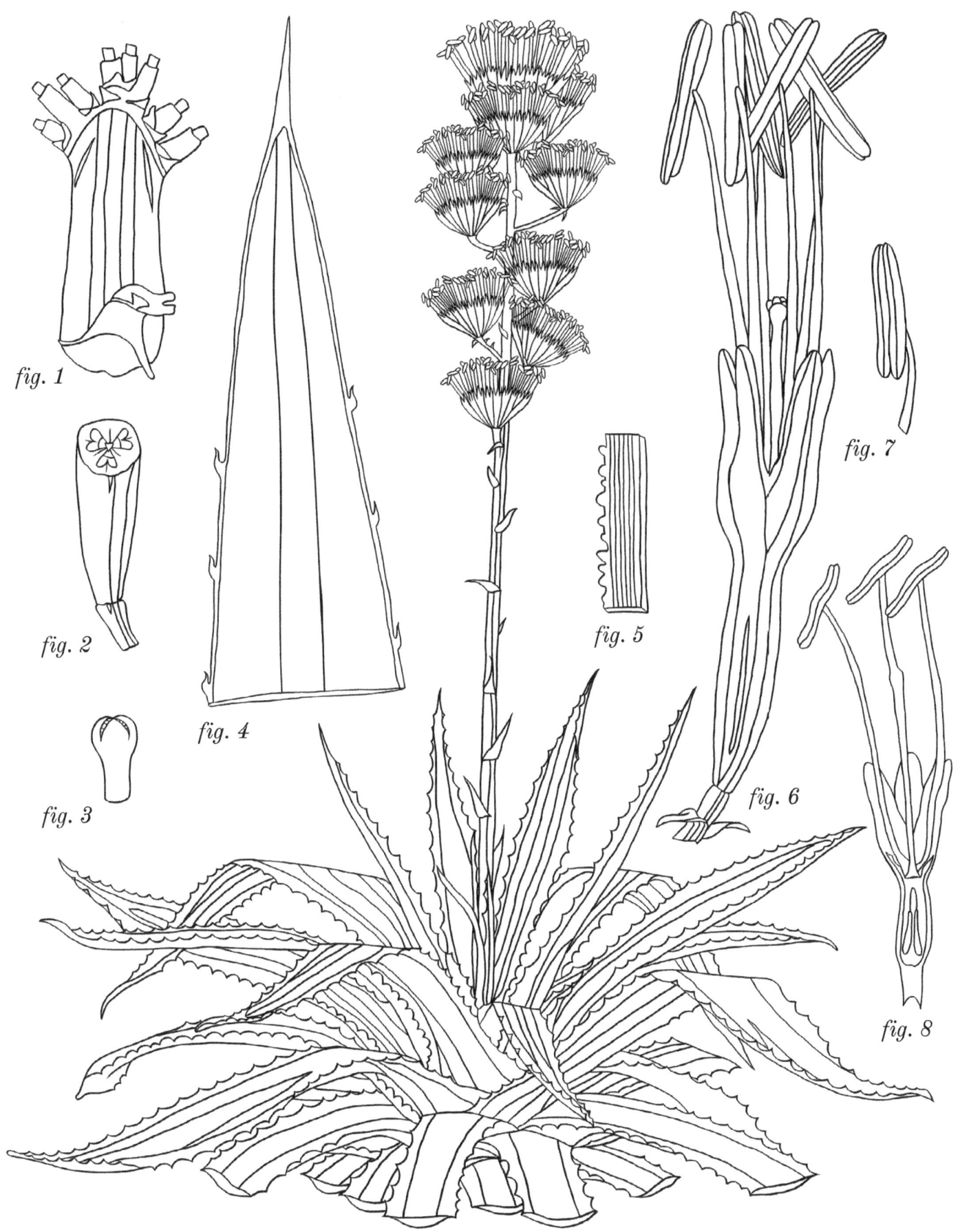

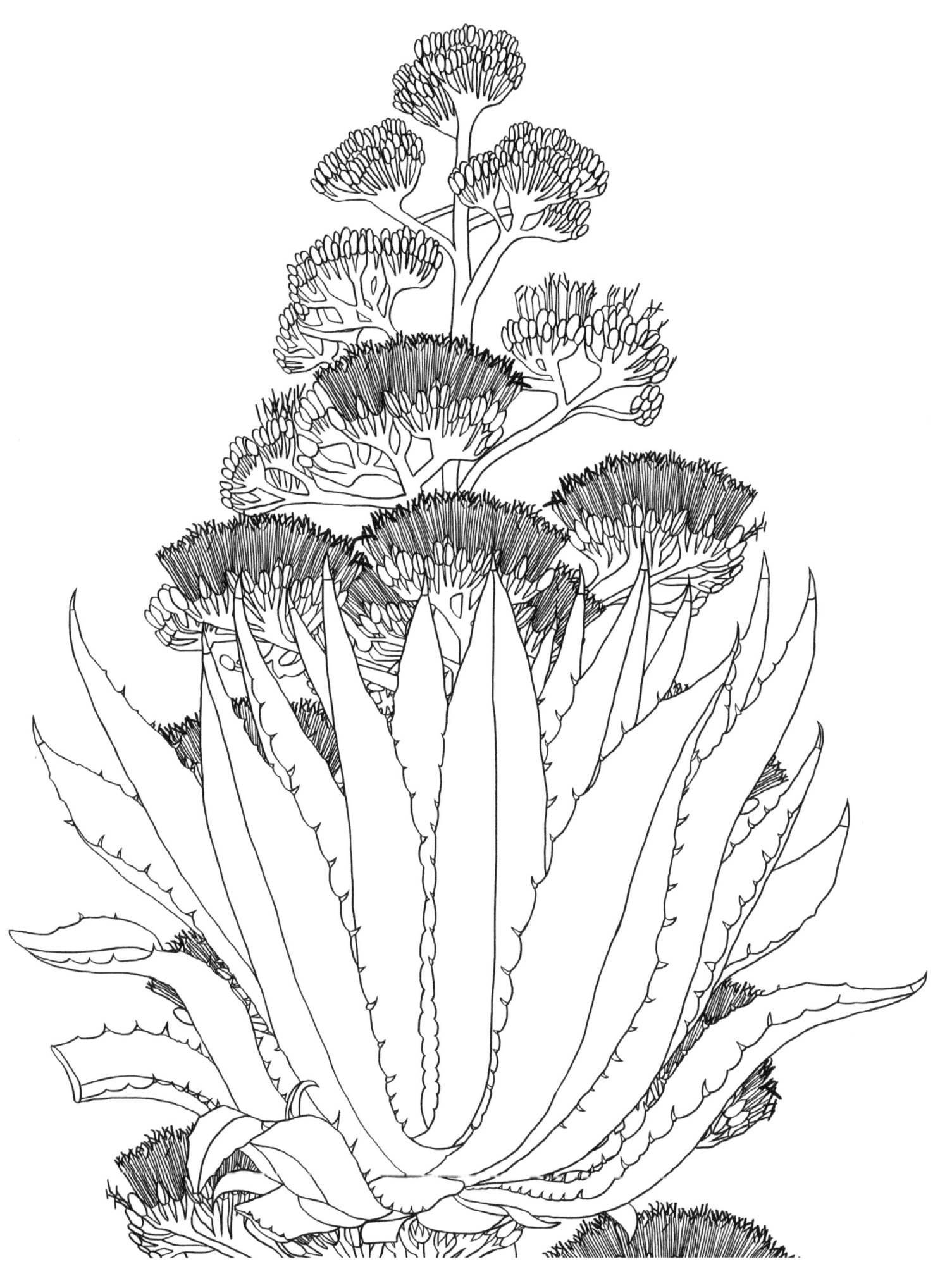

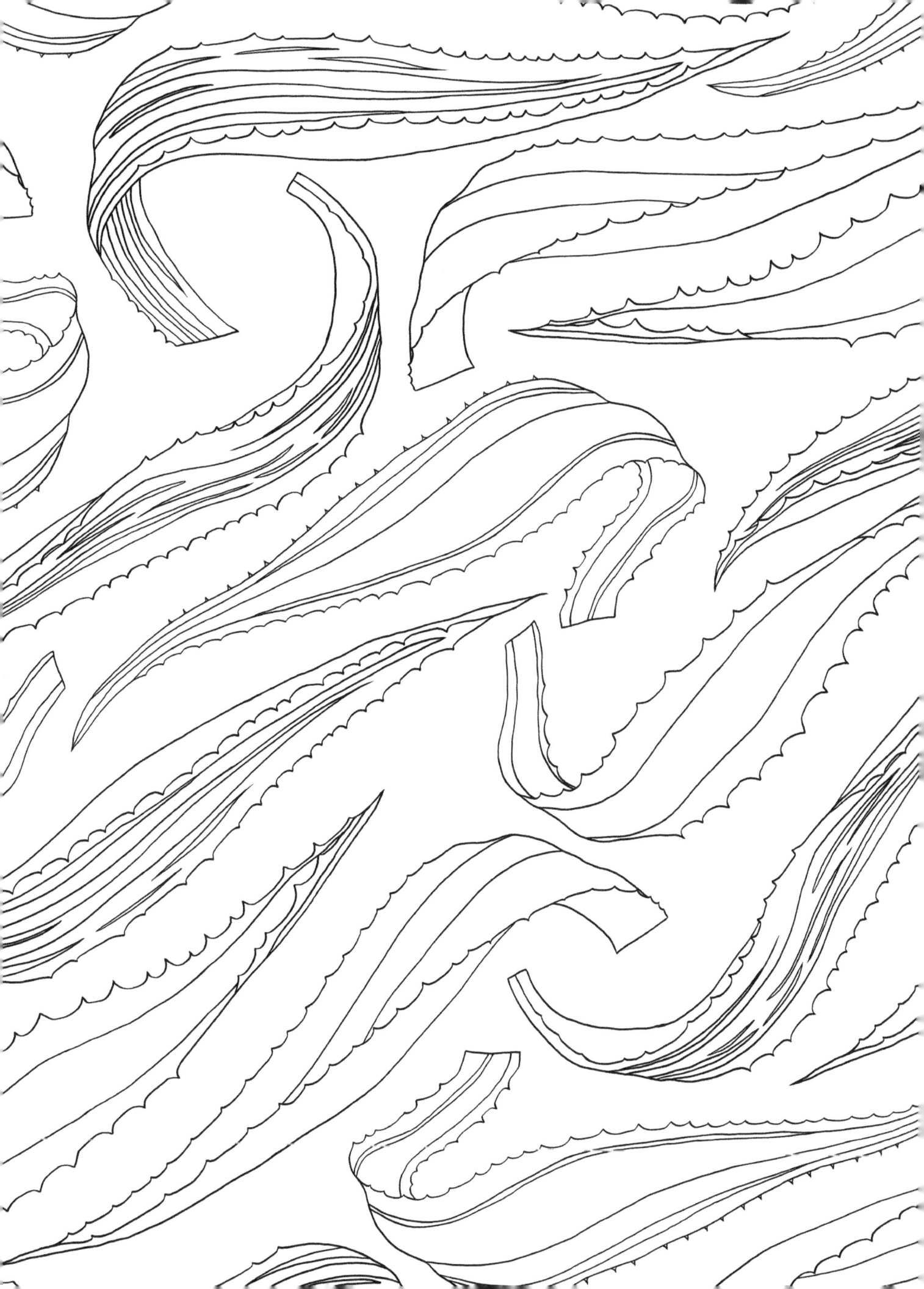

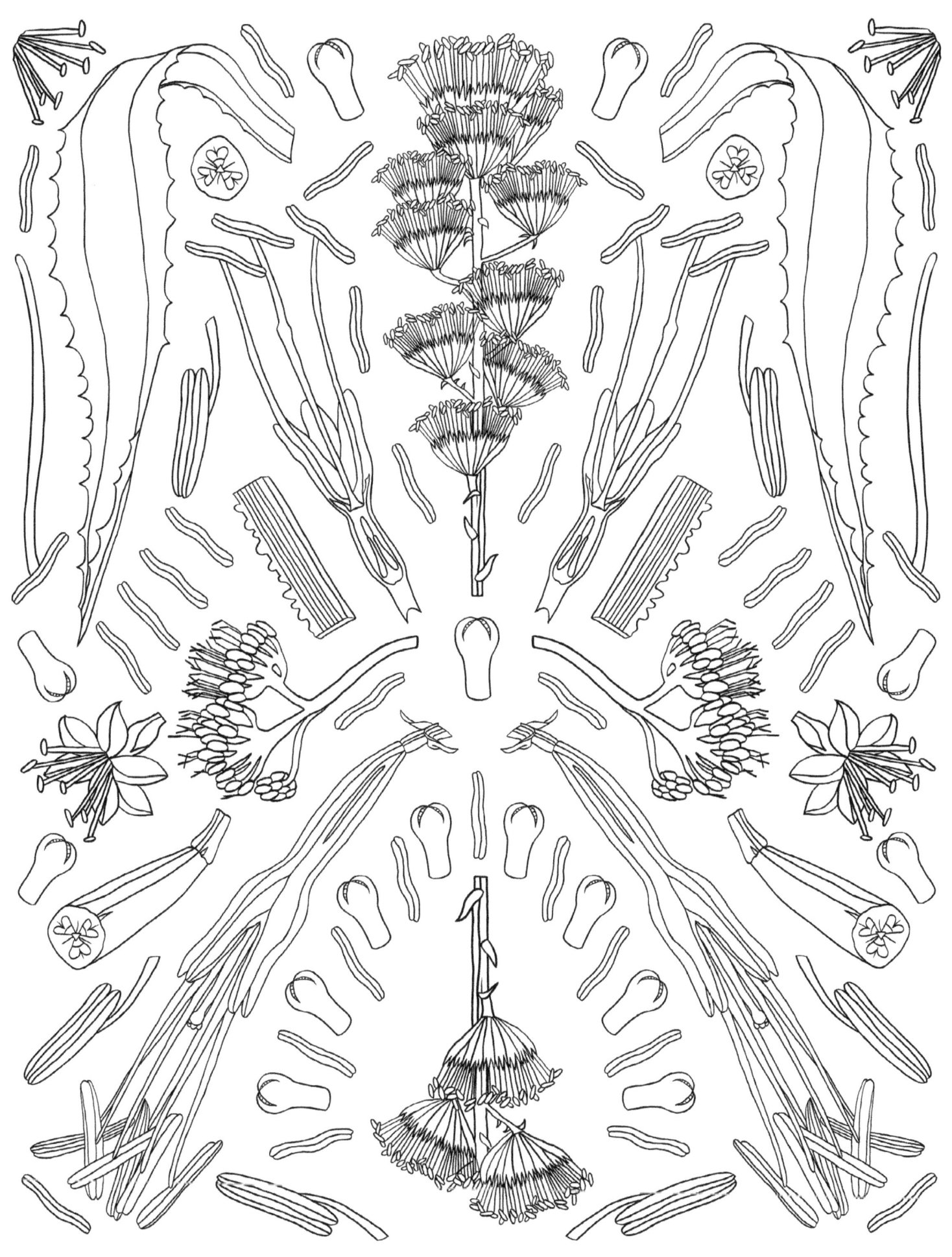

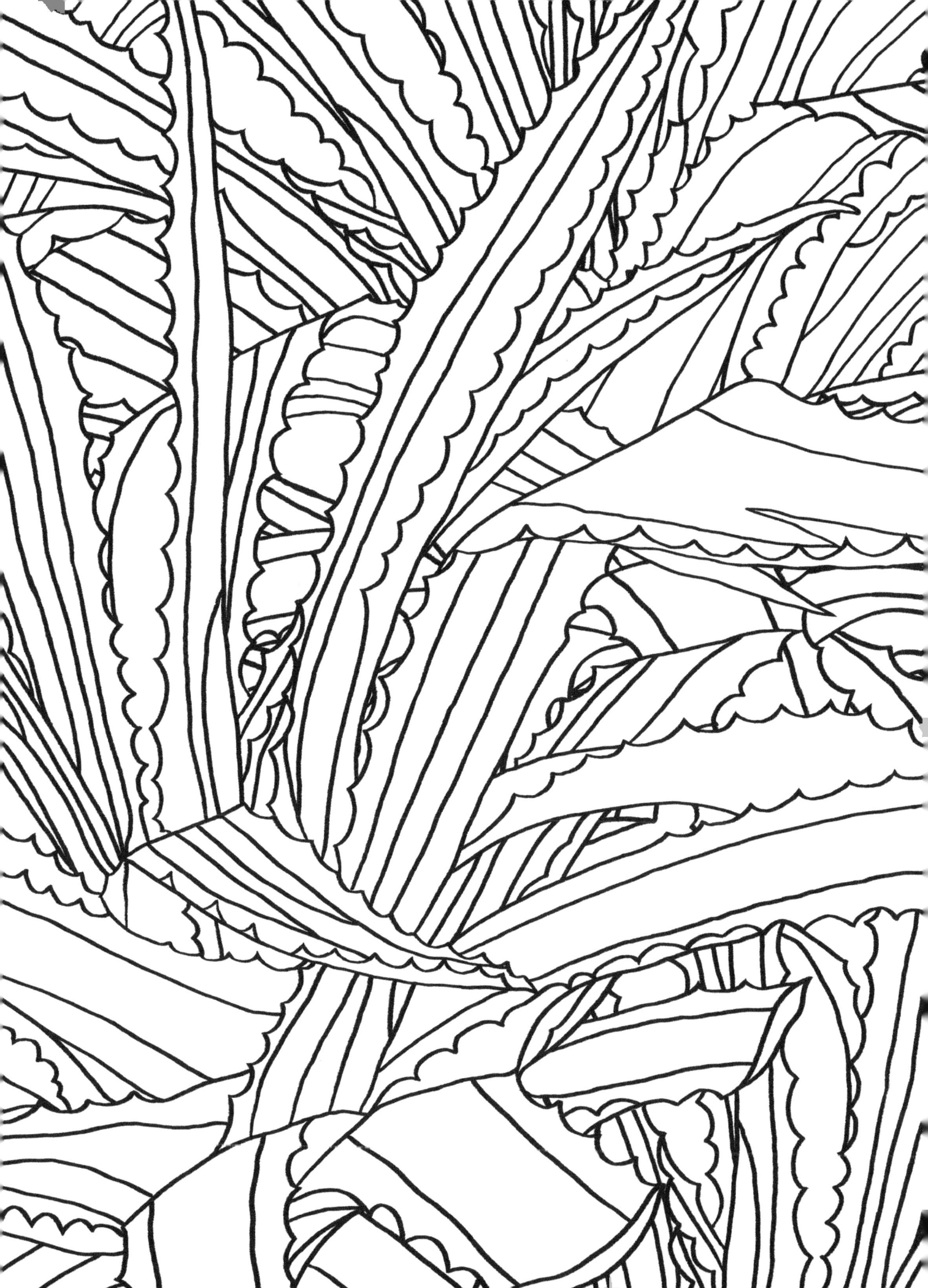

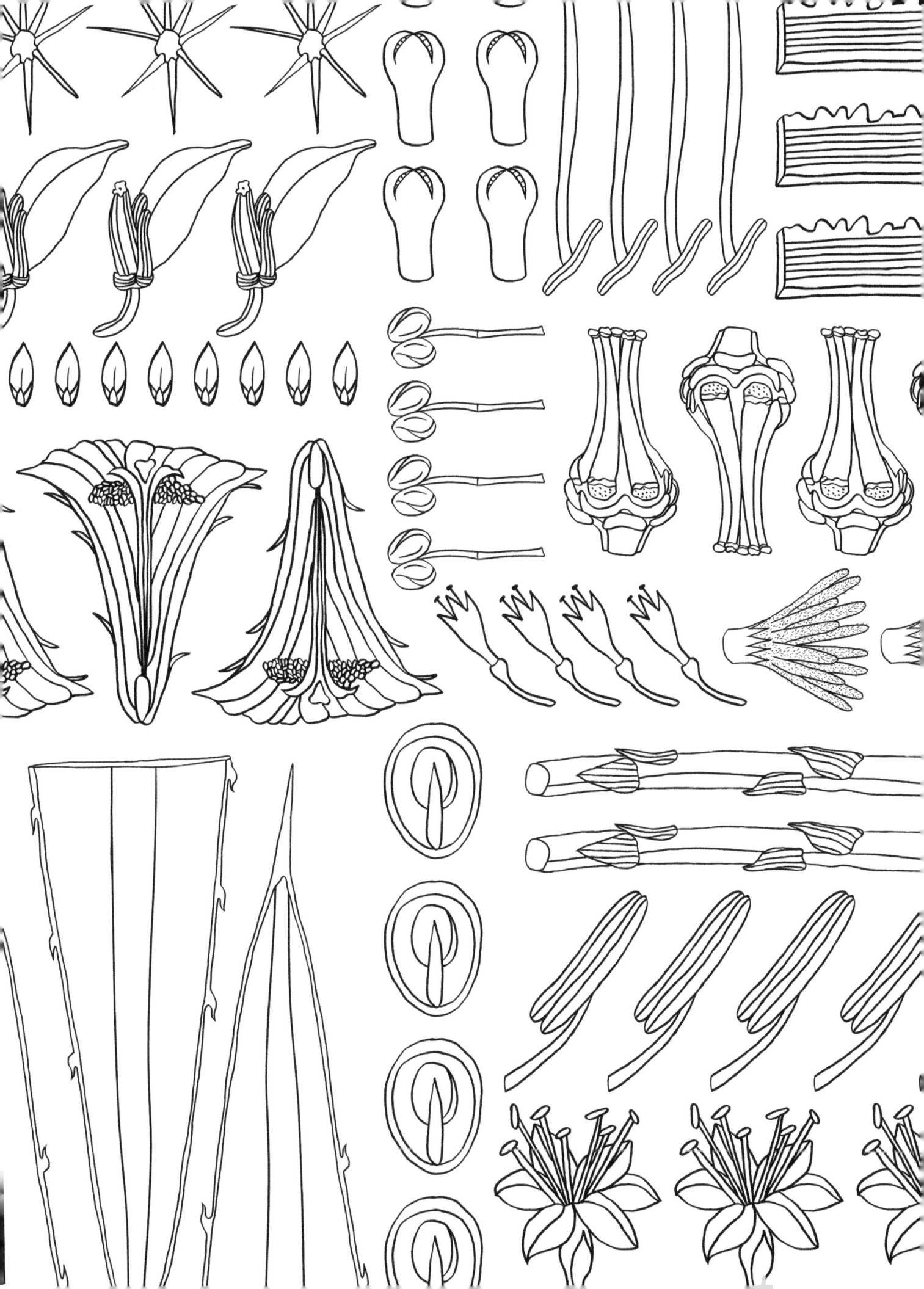

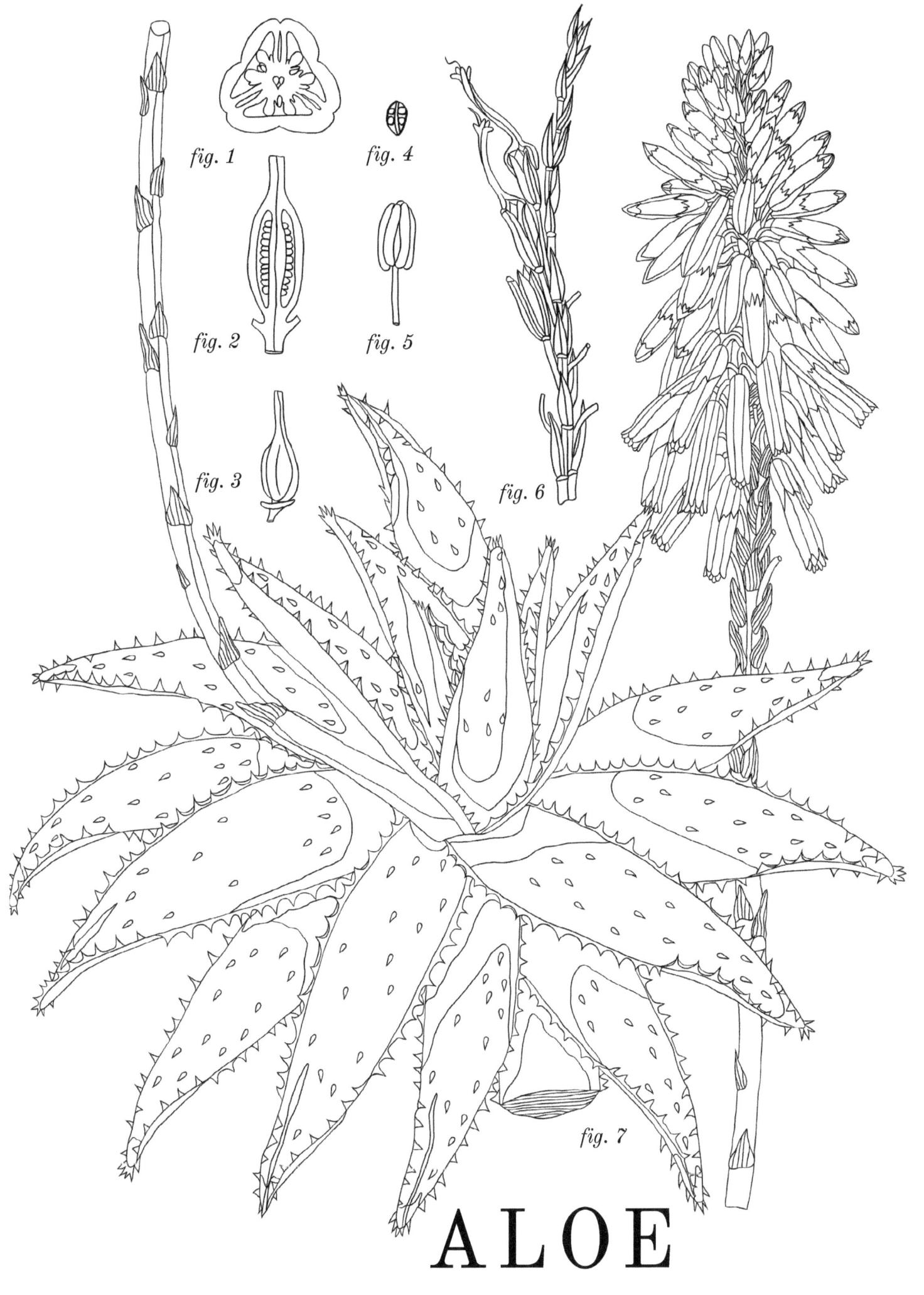

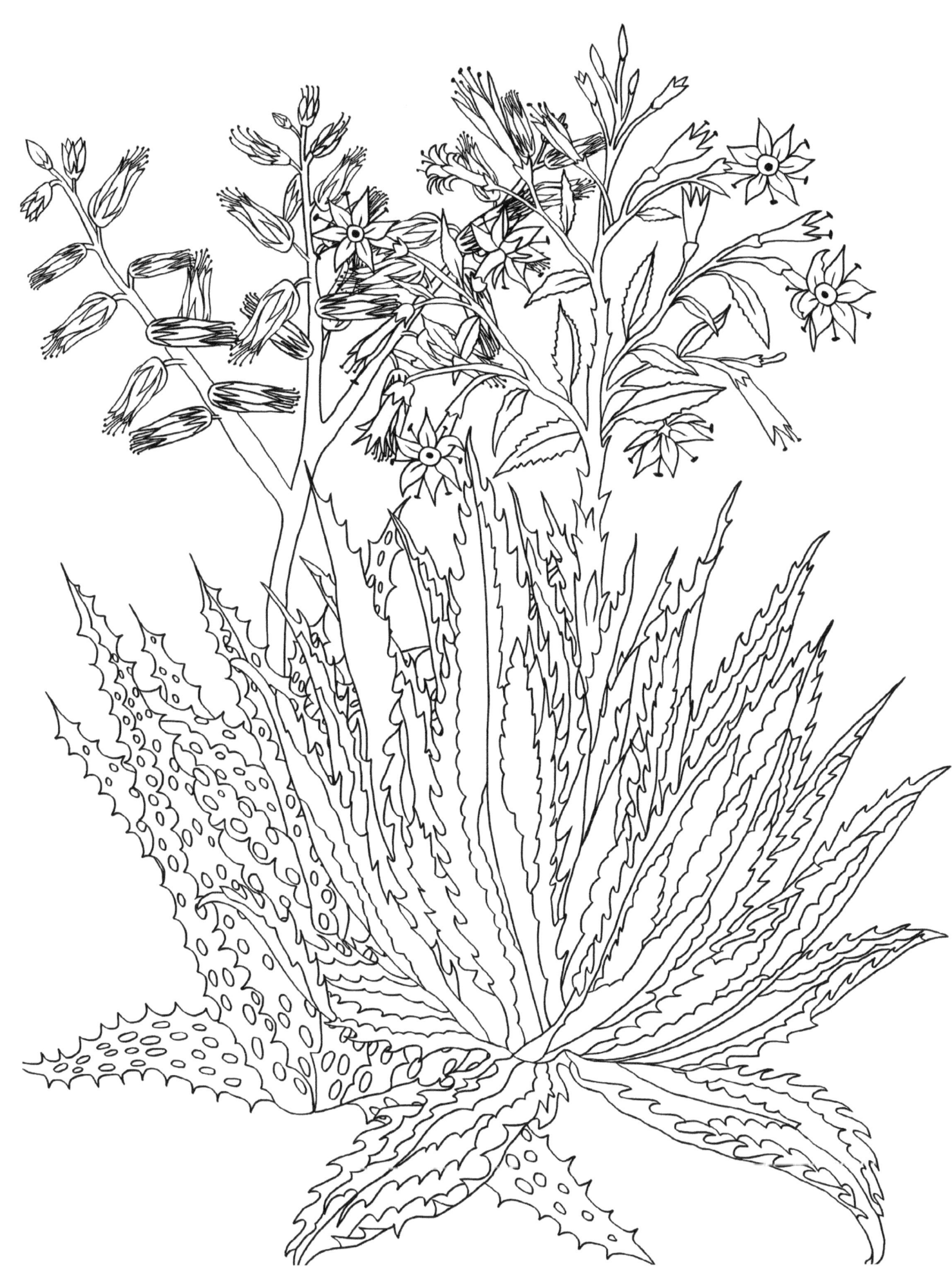

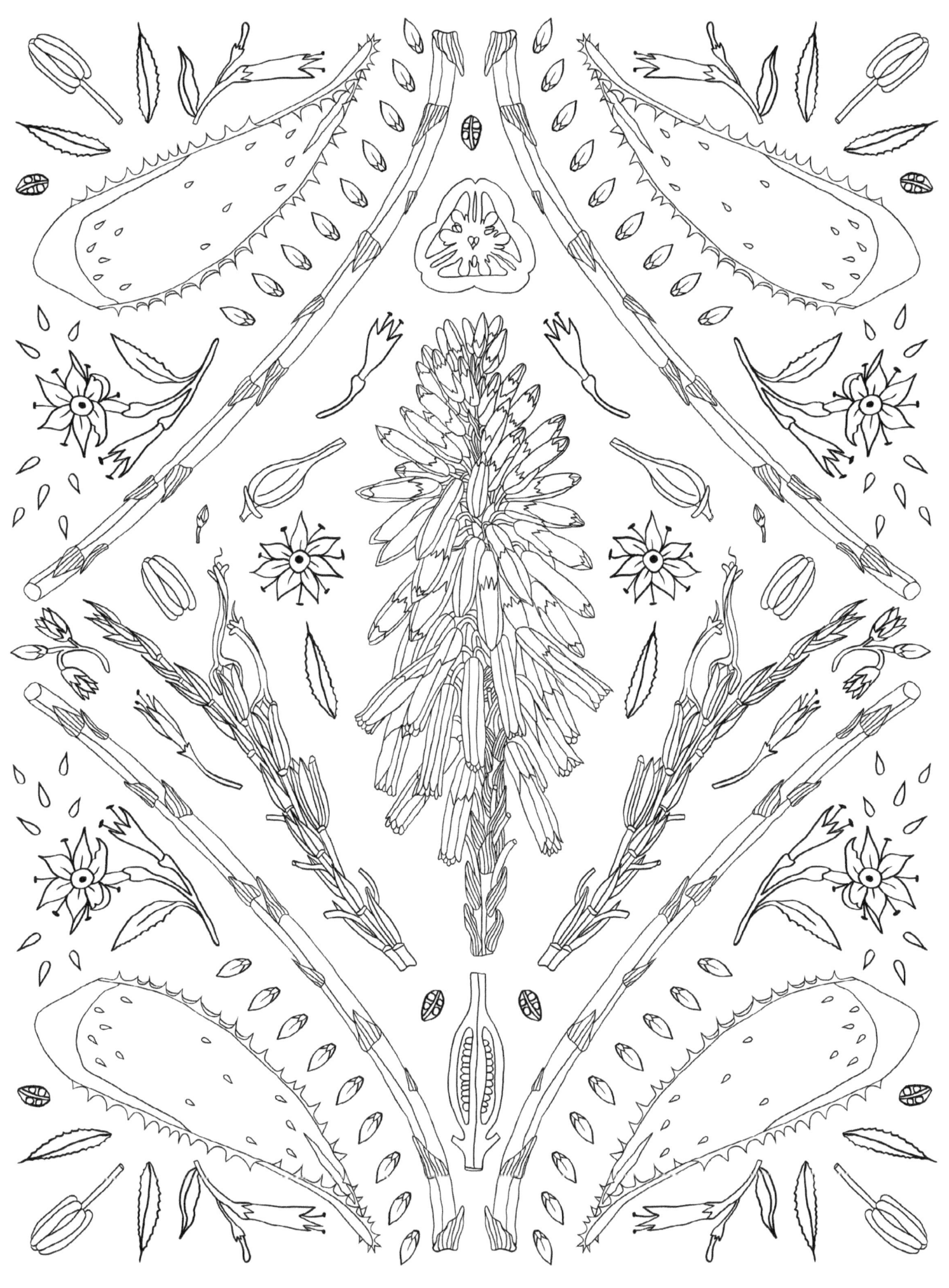

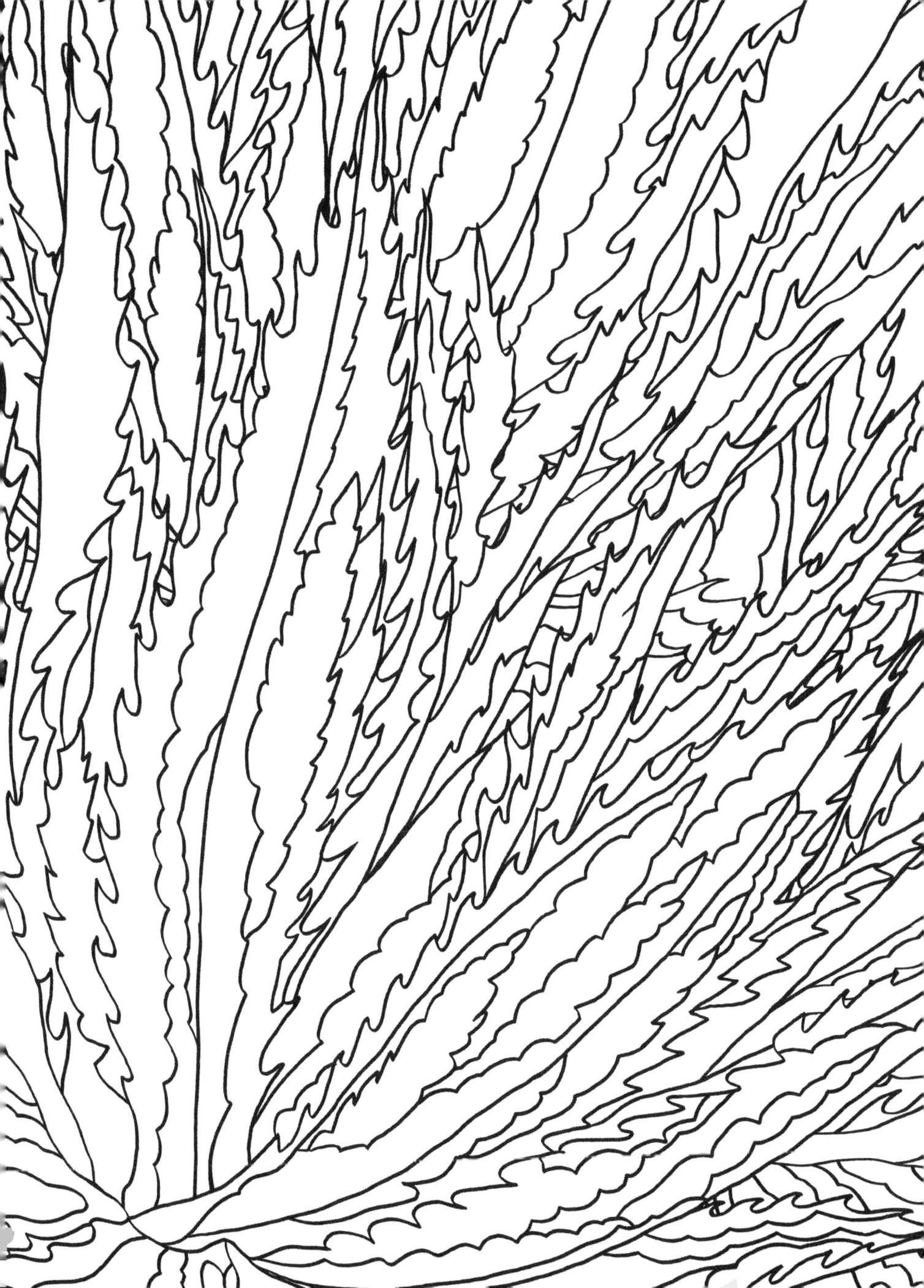

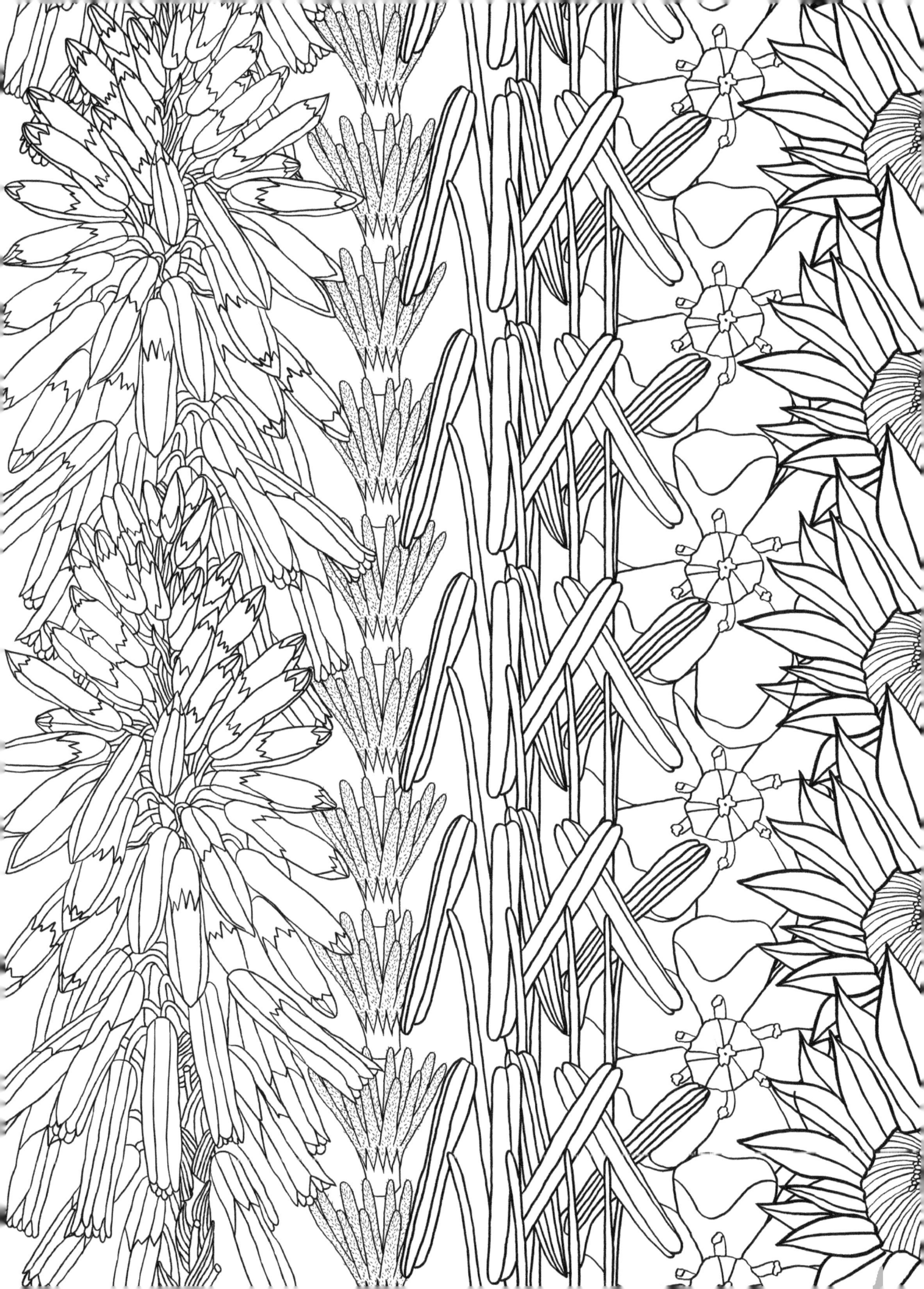

CATHEDRAL CACTUS

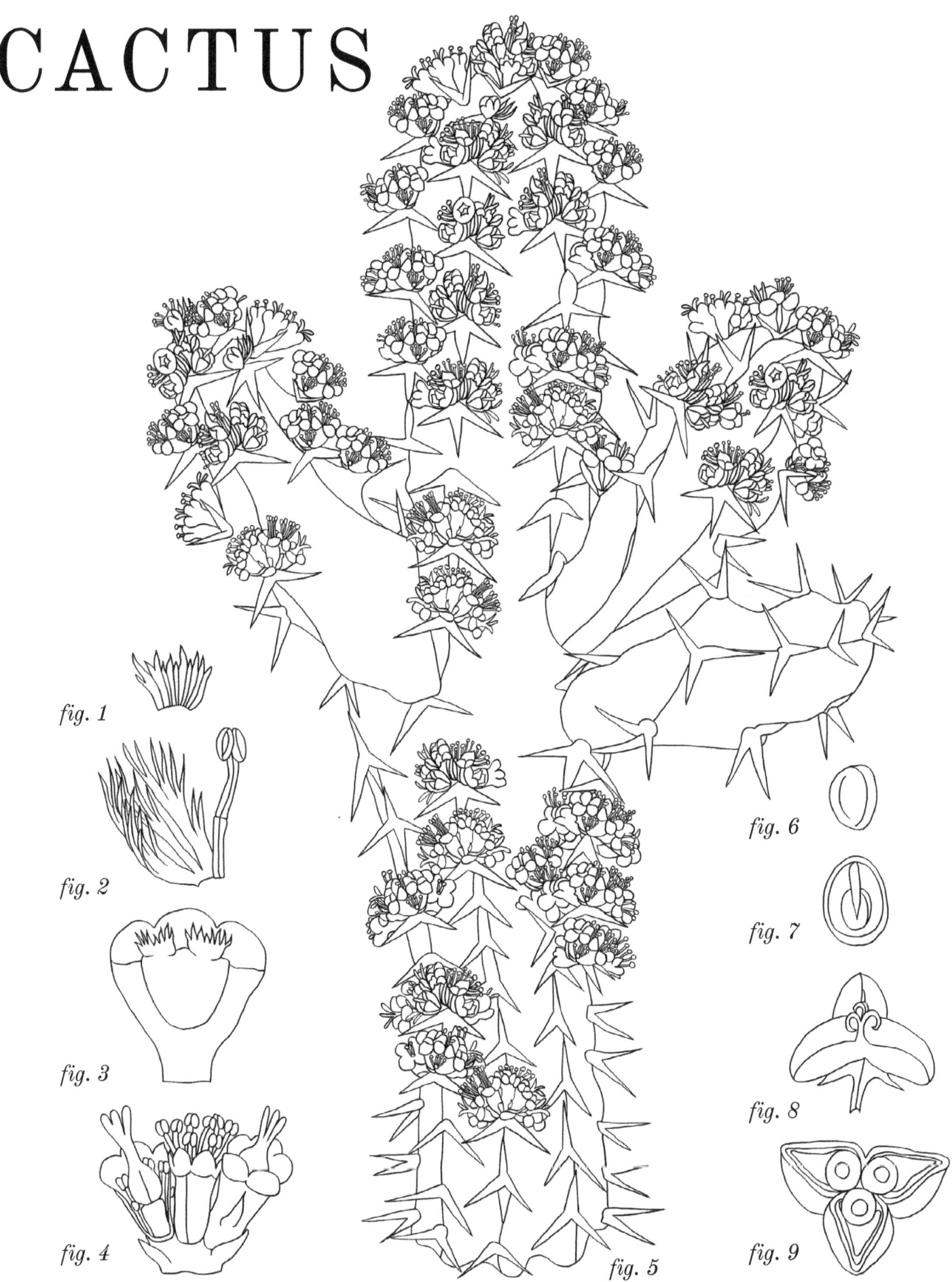

fig. 1
fig. 2
fig. 3
fig. 4
fig. 5
fig. 6
fig. 7
fig. 8
fig. 9

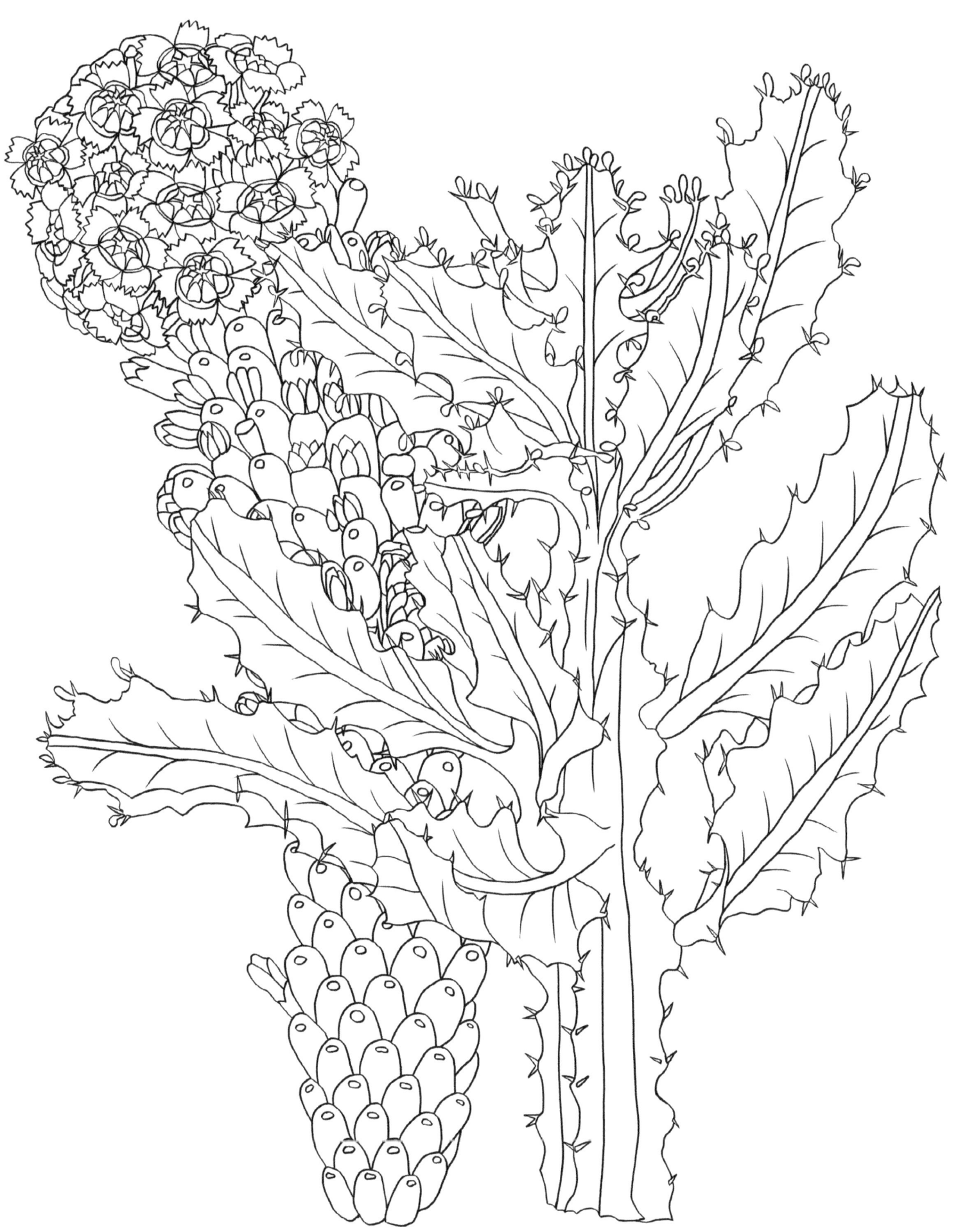

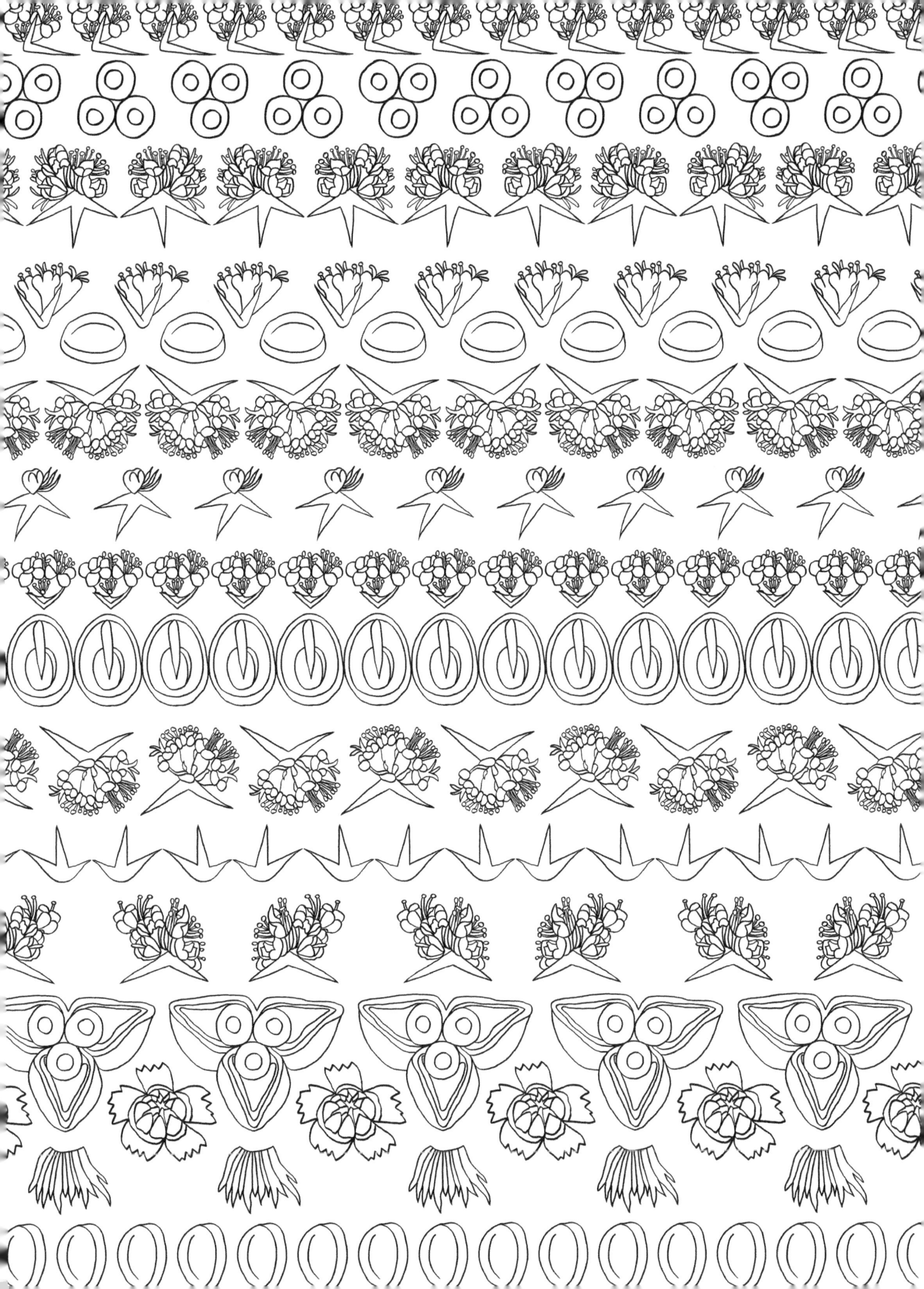

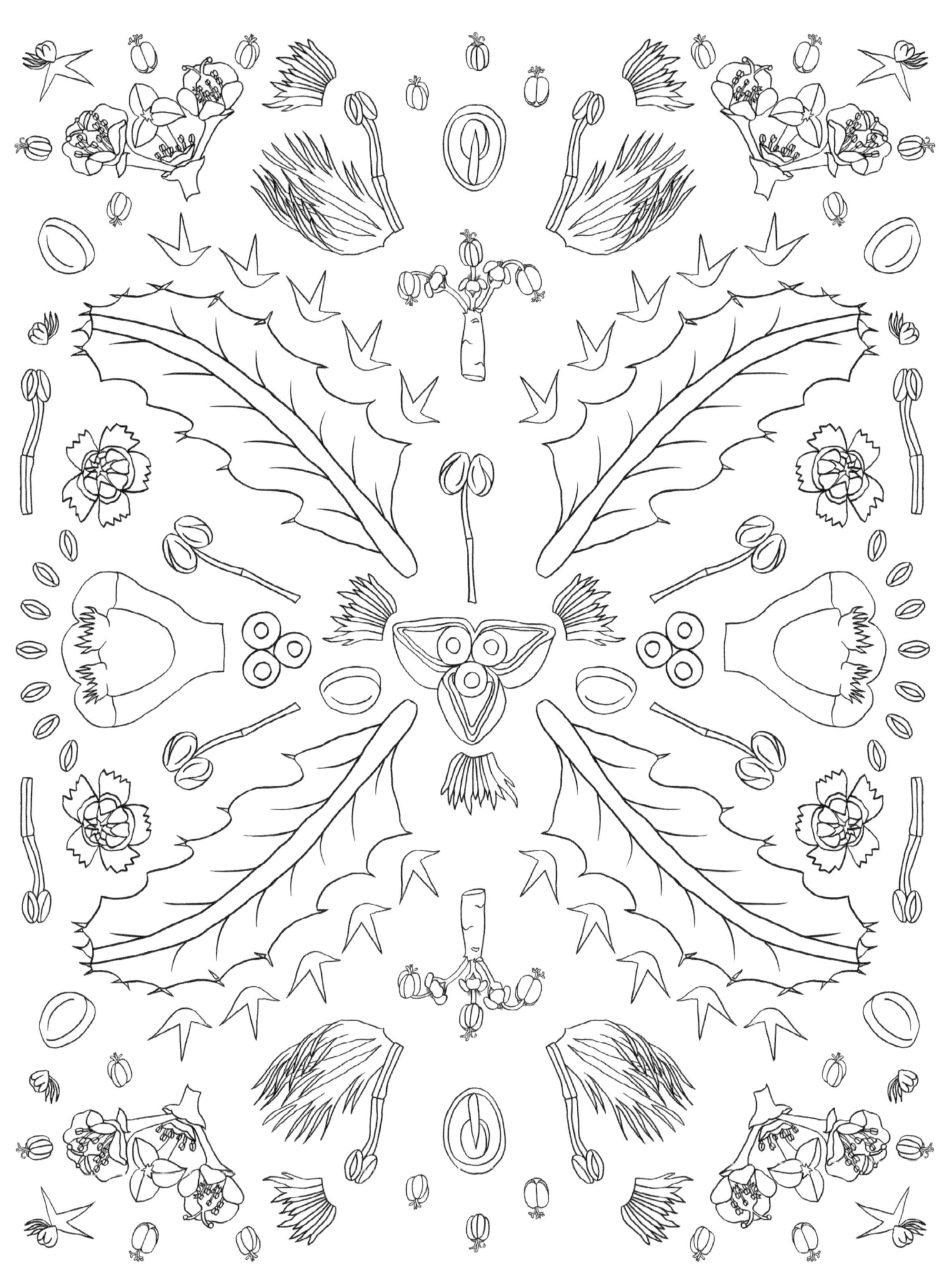

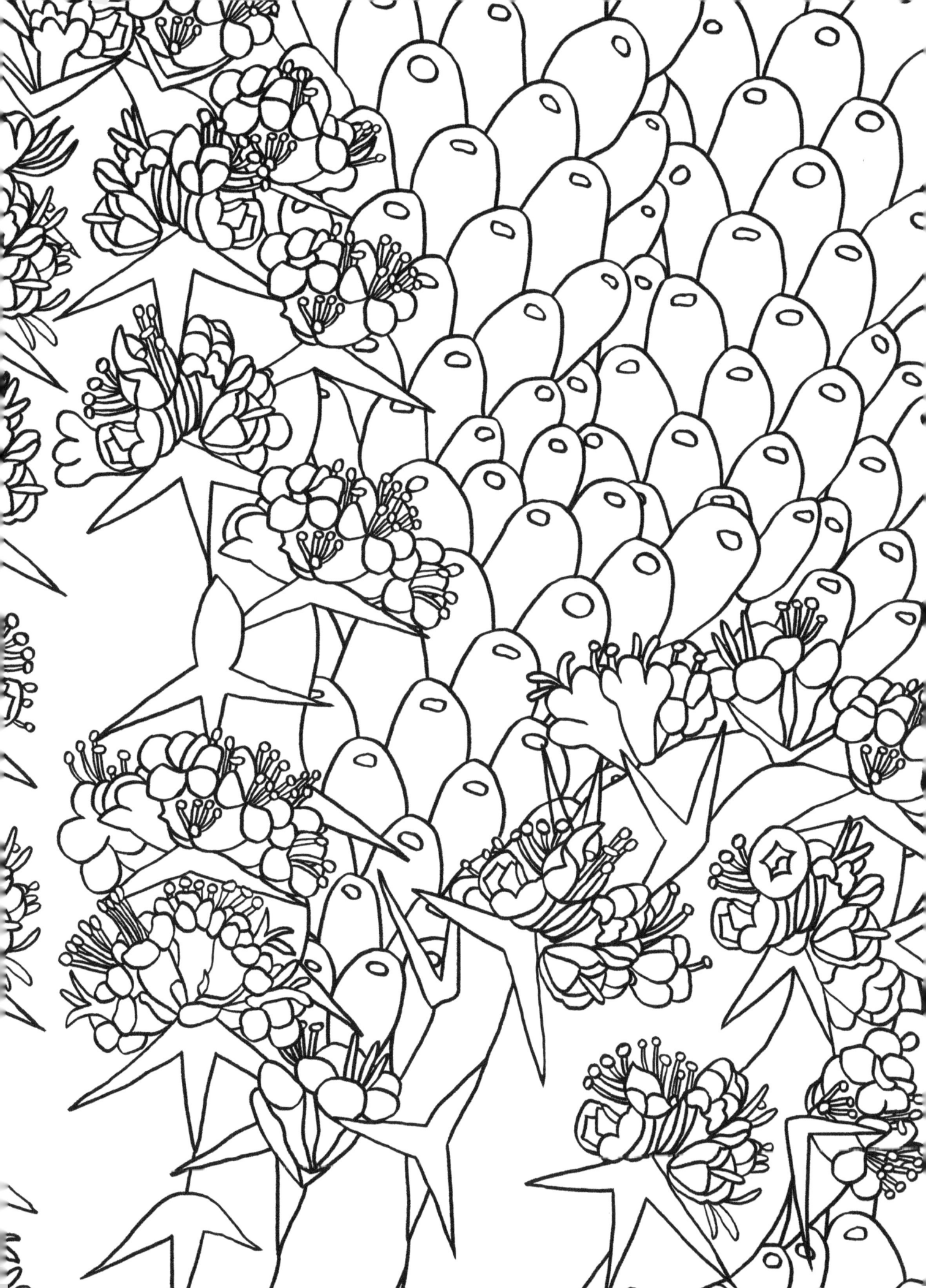

CLIMBING CACTUS

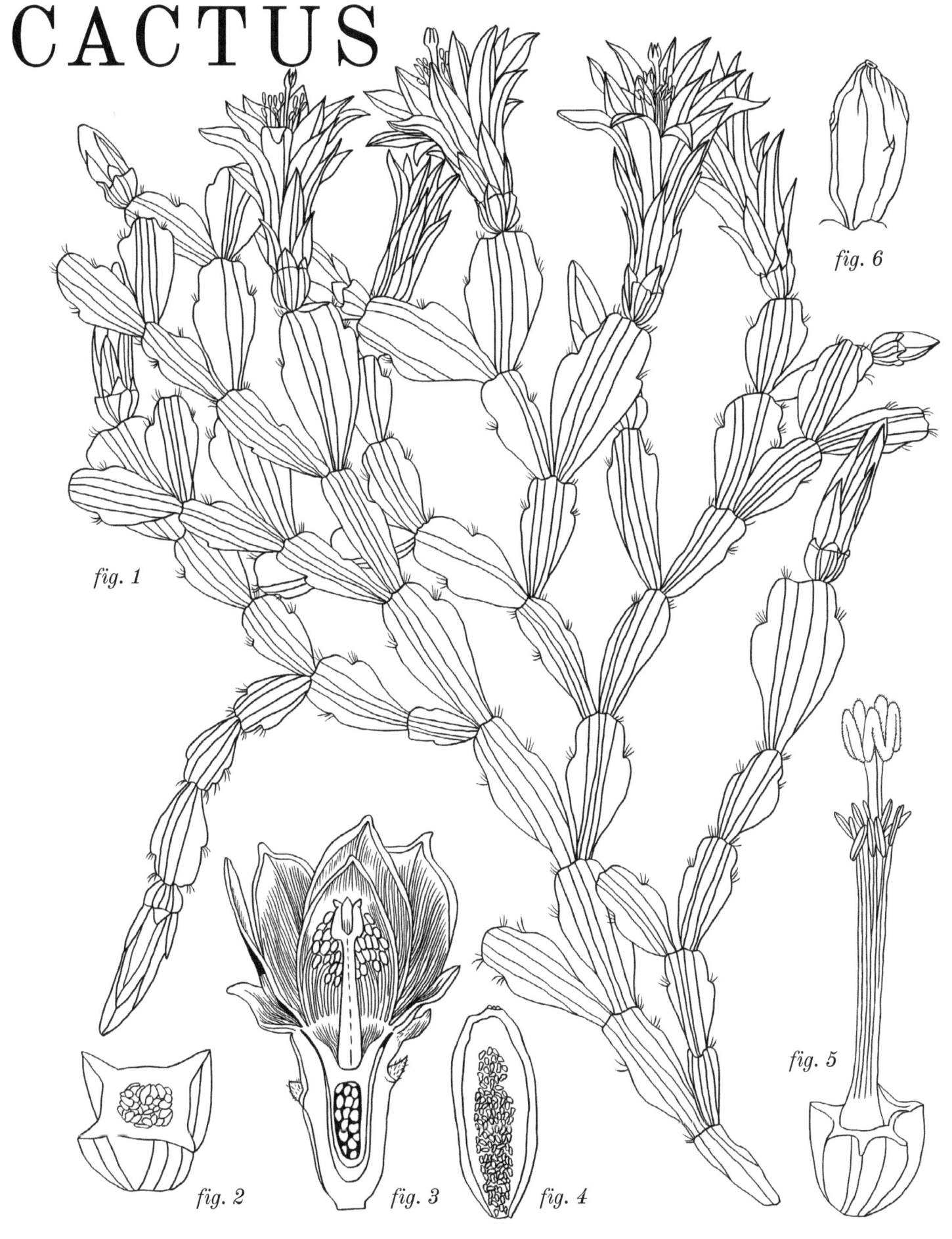

fig. 1
fig. 2
fig. 3
fig. 4
fig. 5
fig. 6

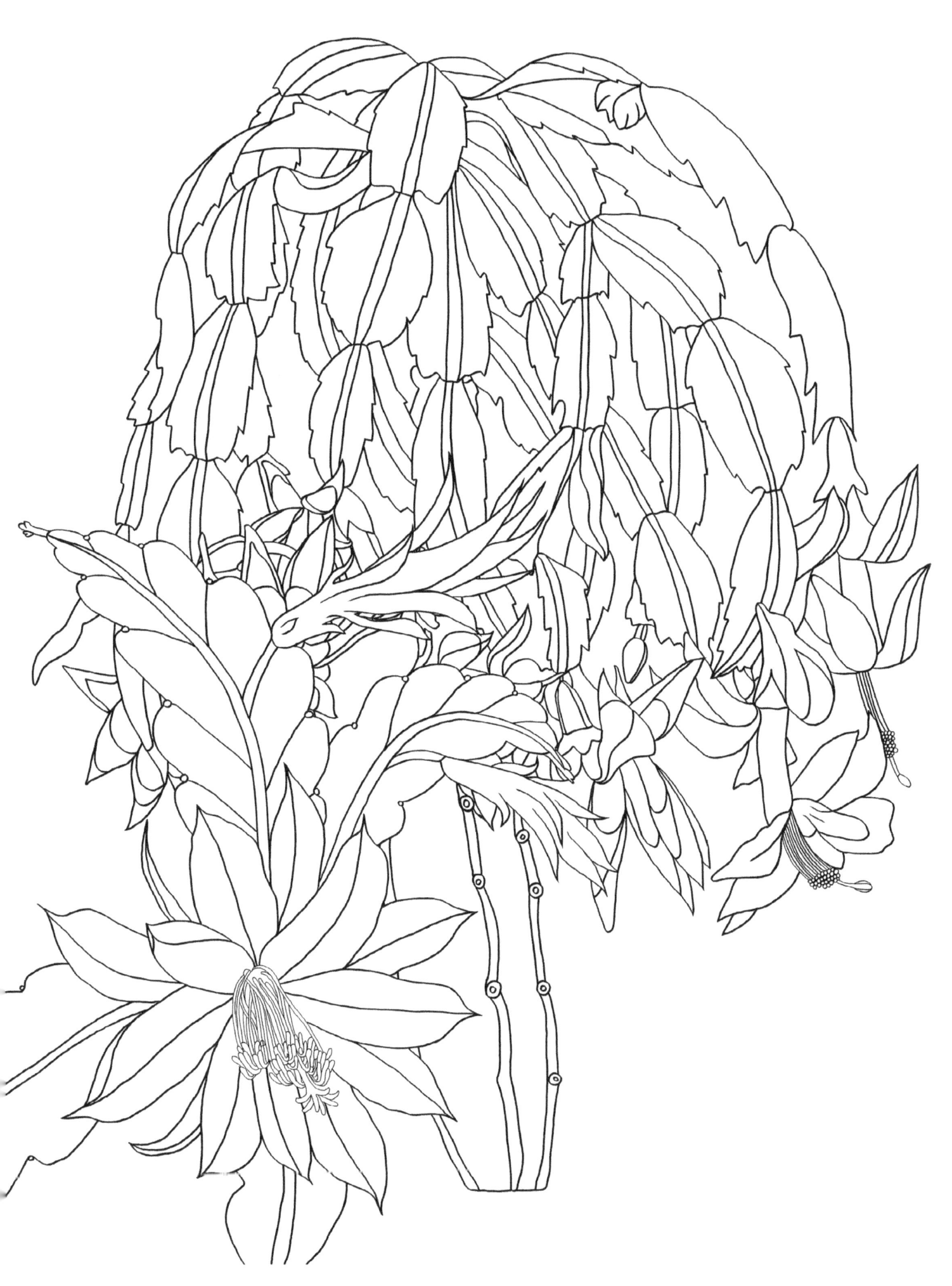

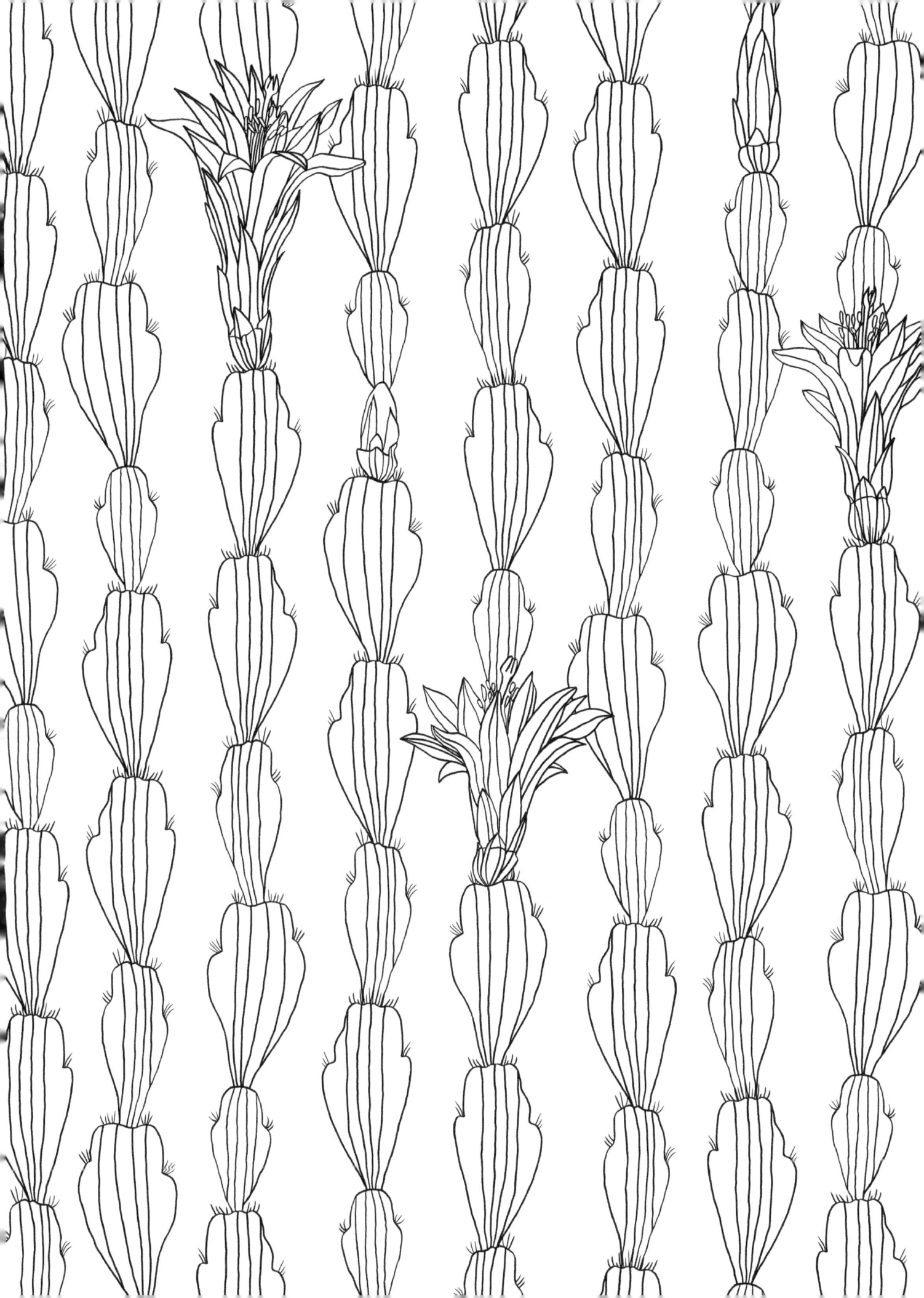

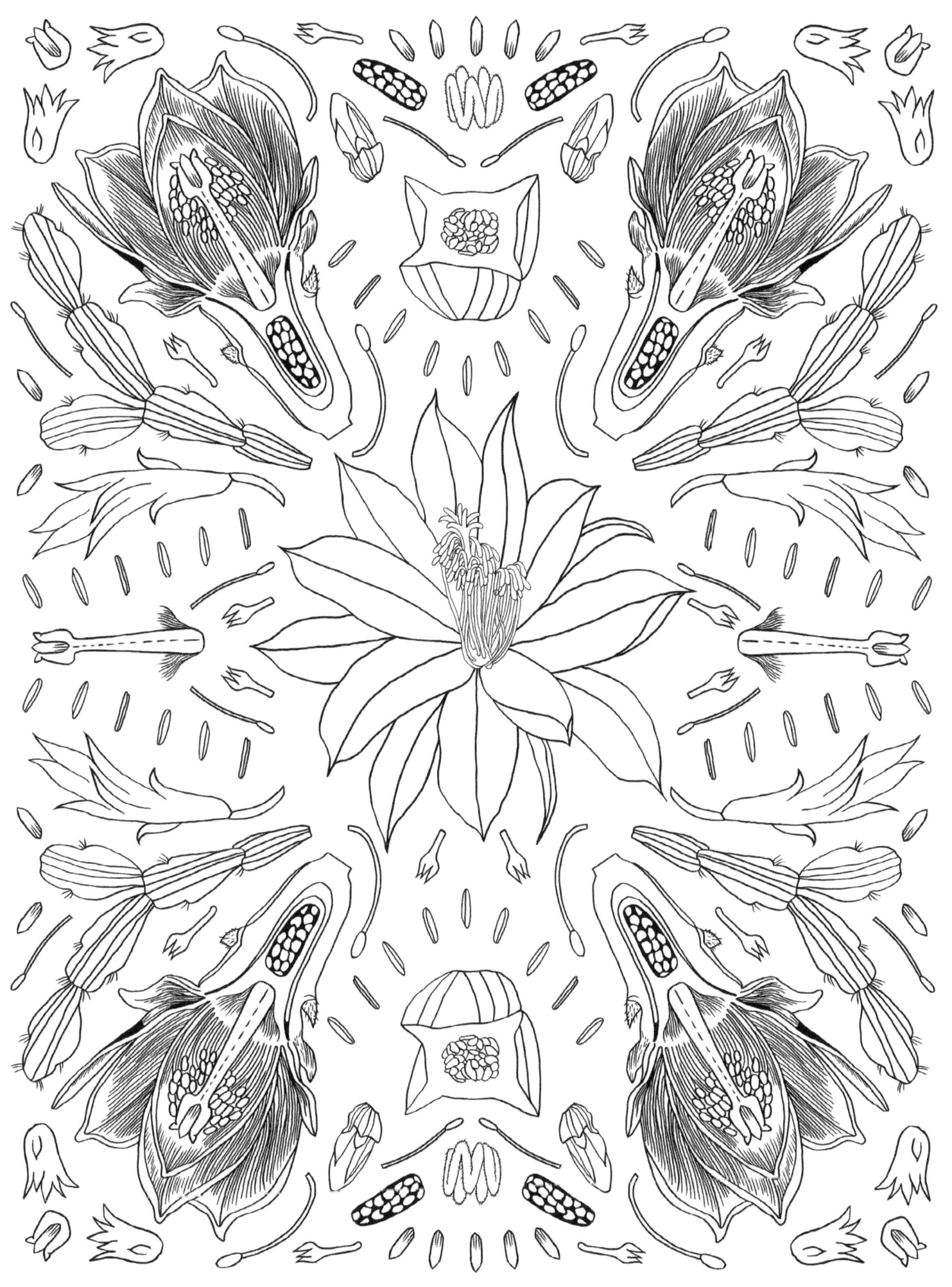

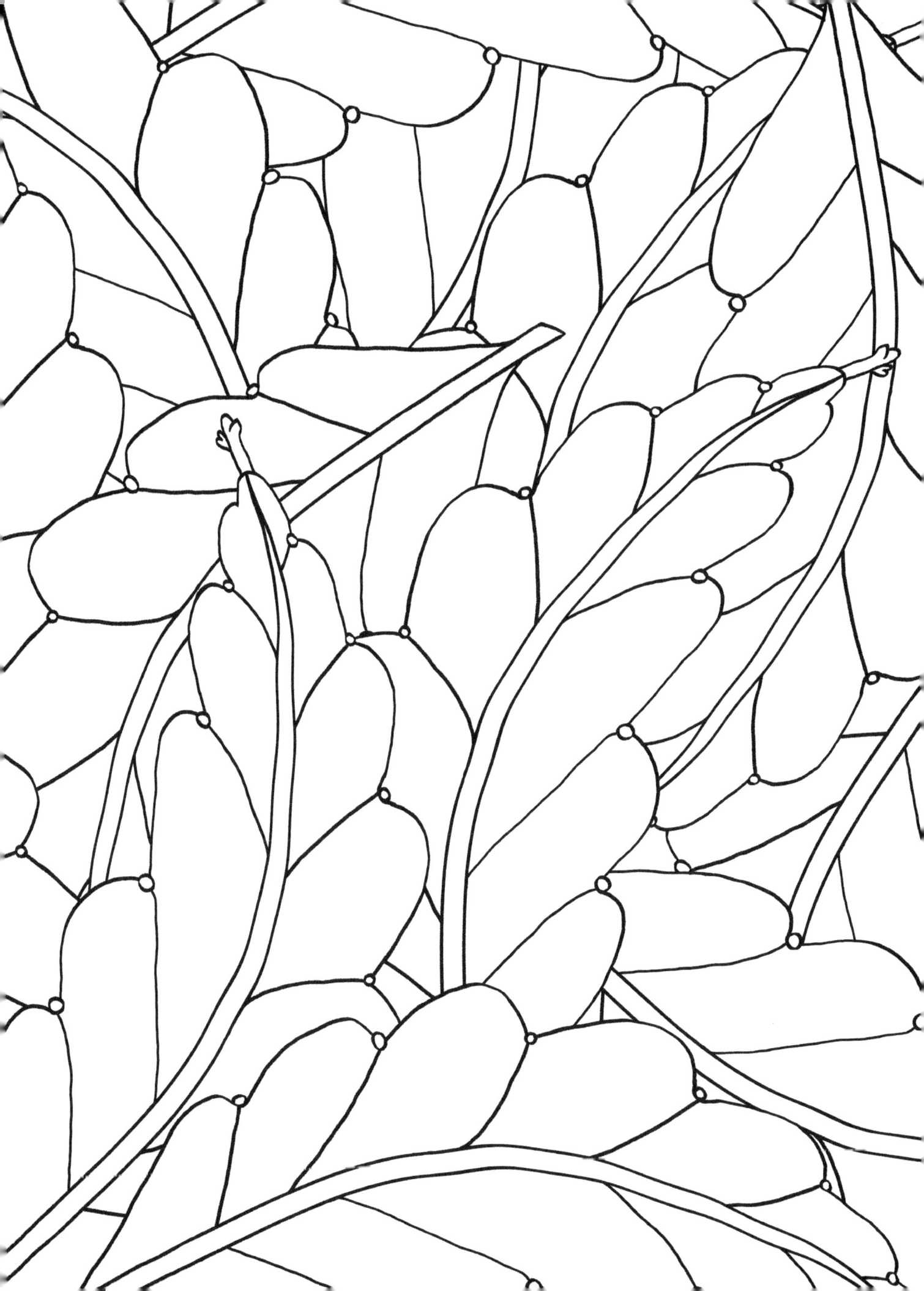

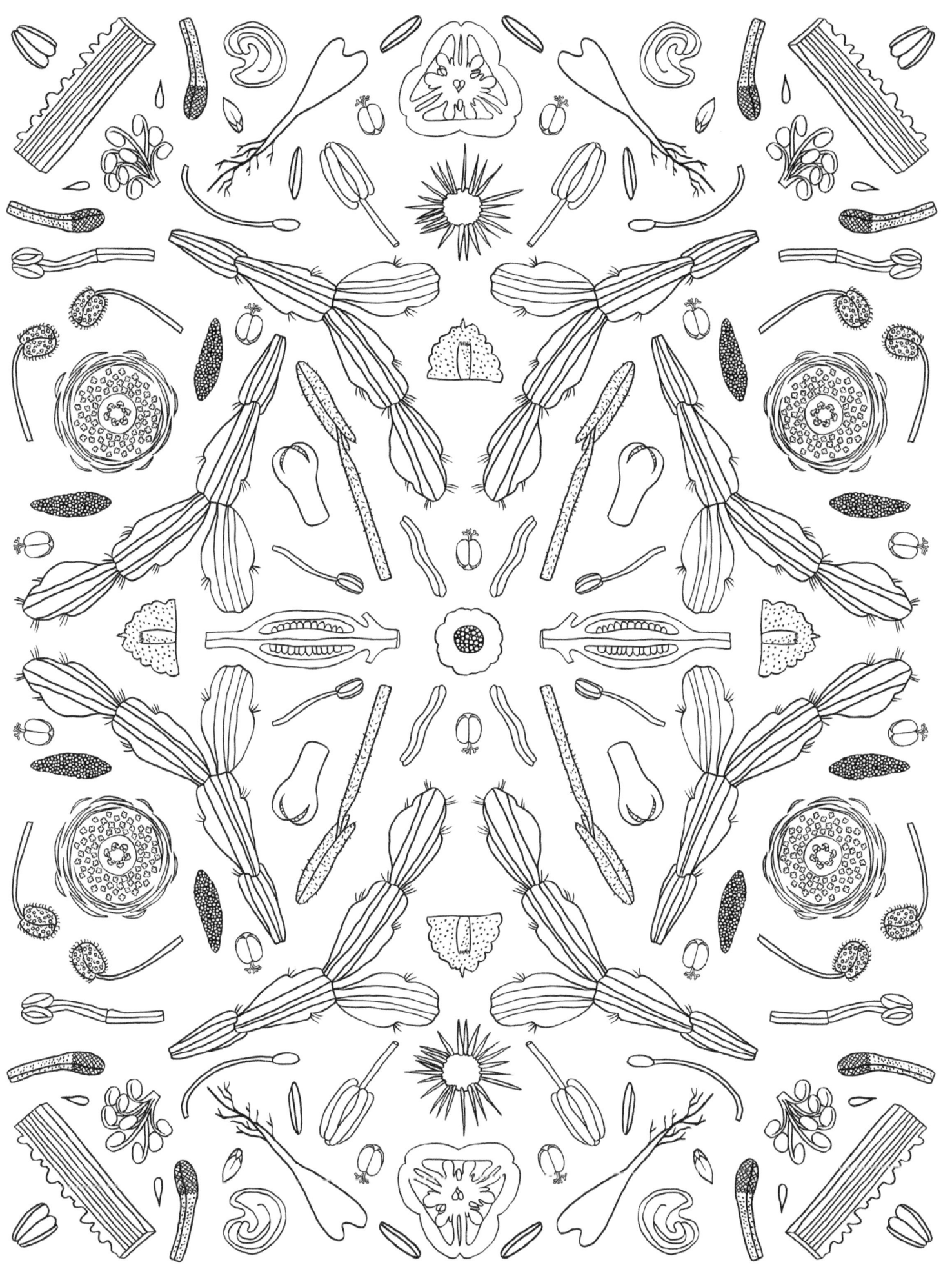

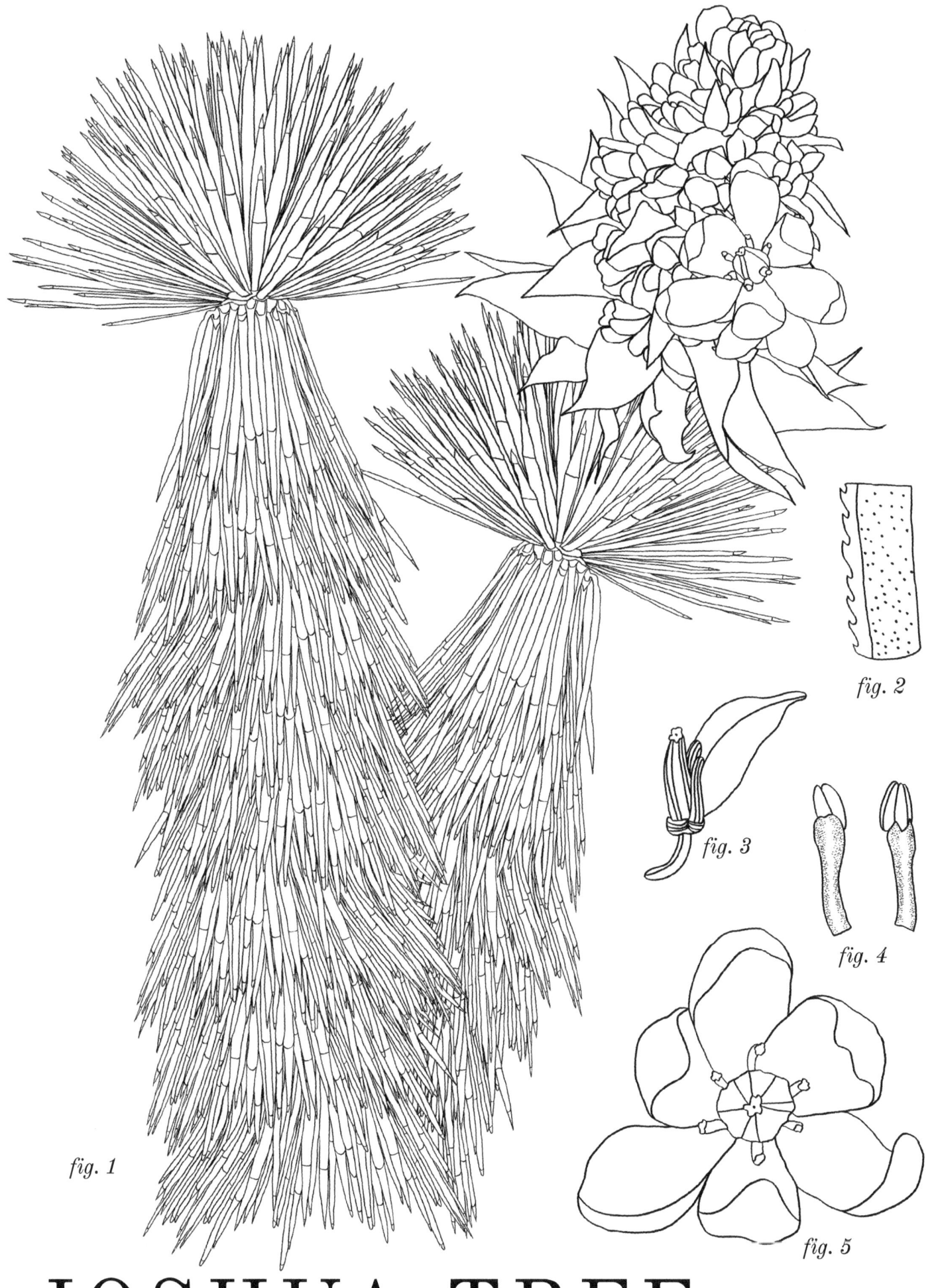

JOSHUA TREE

fig. 1
fig. 2
fig. 3
fig. 4
fig. 5

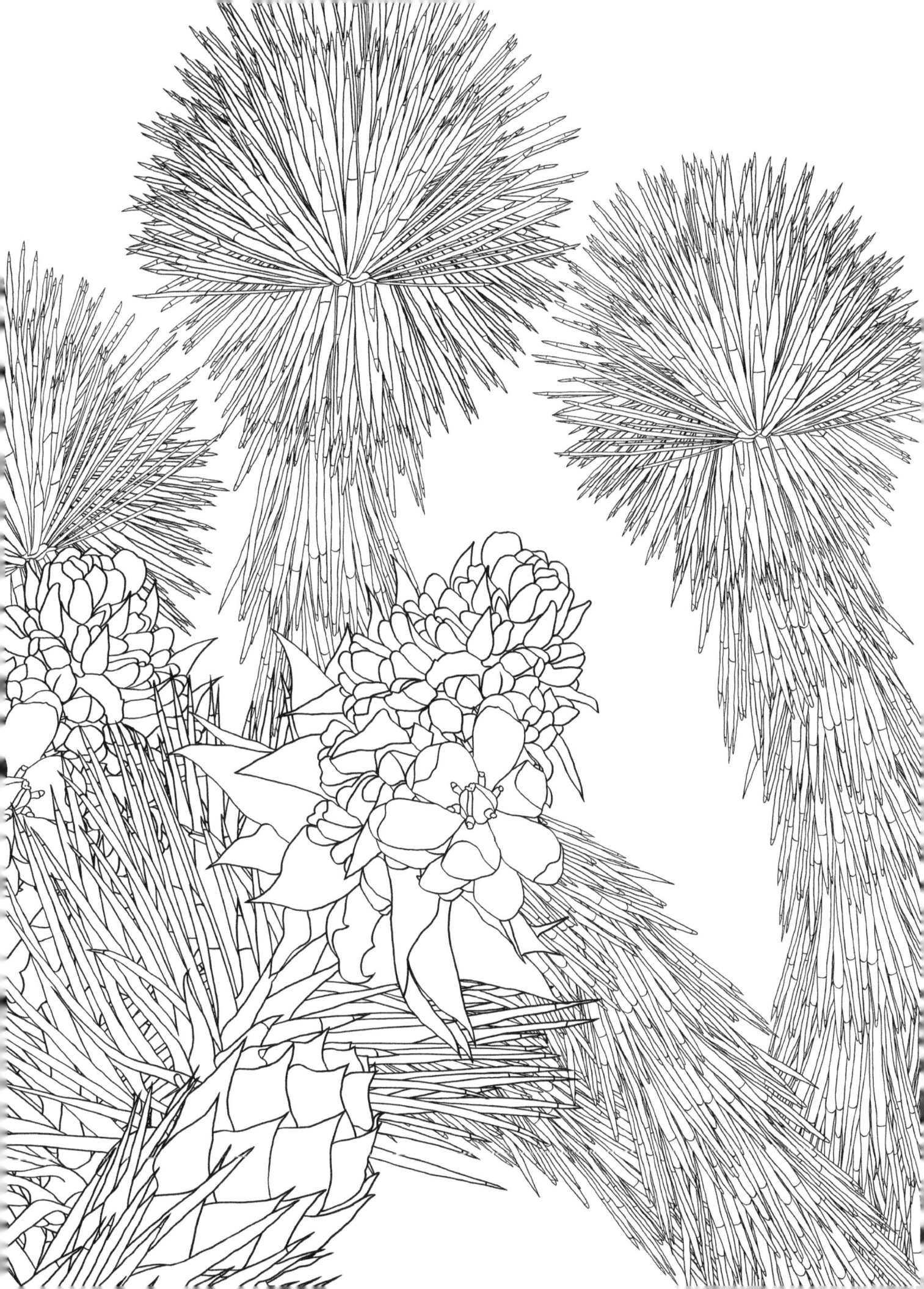

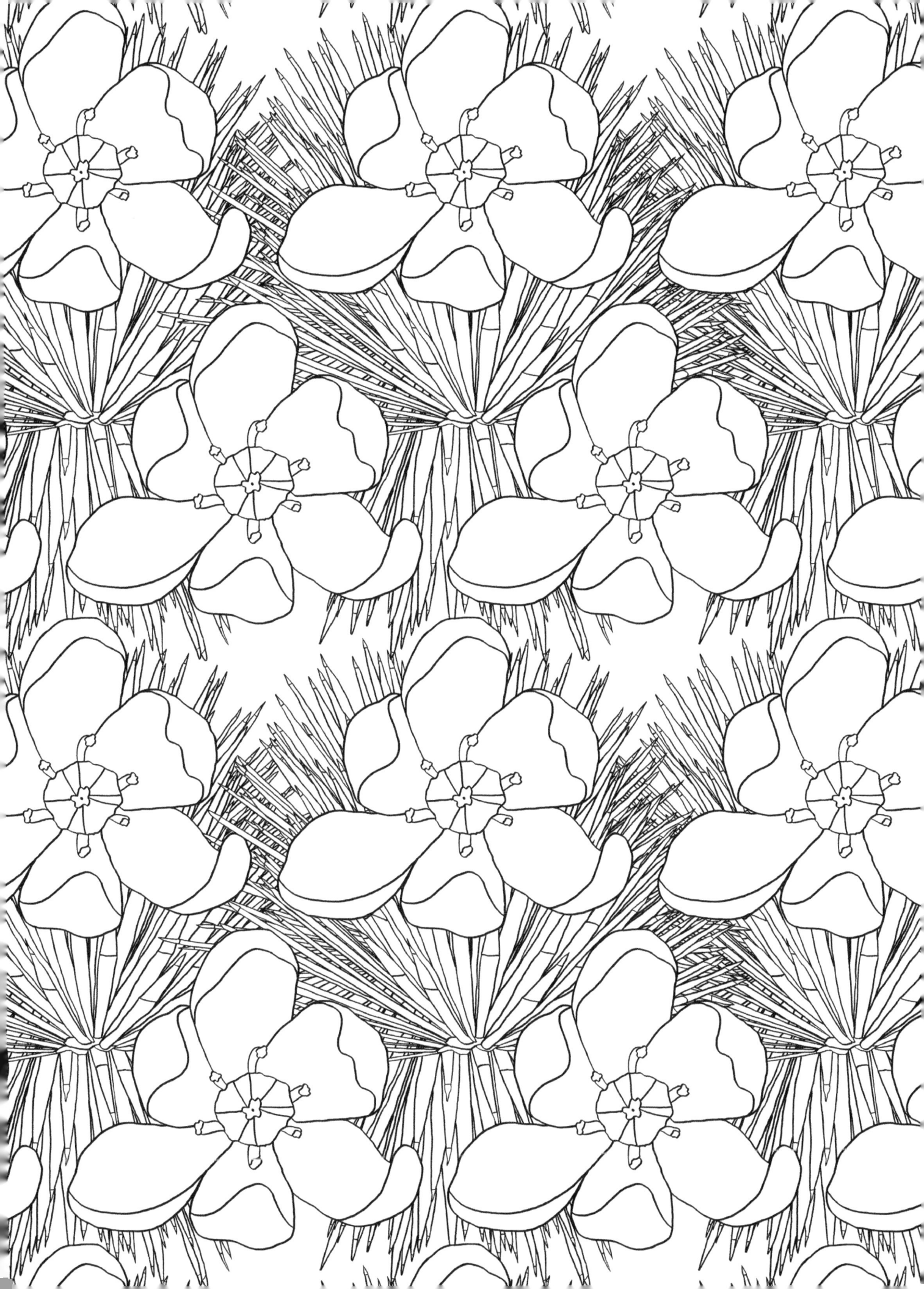

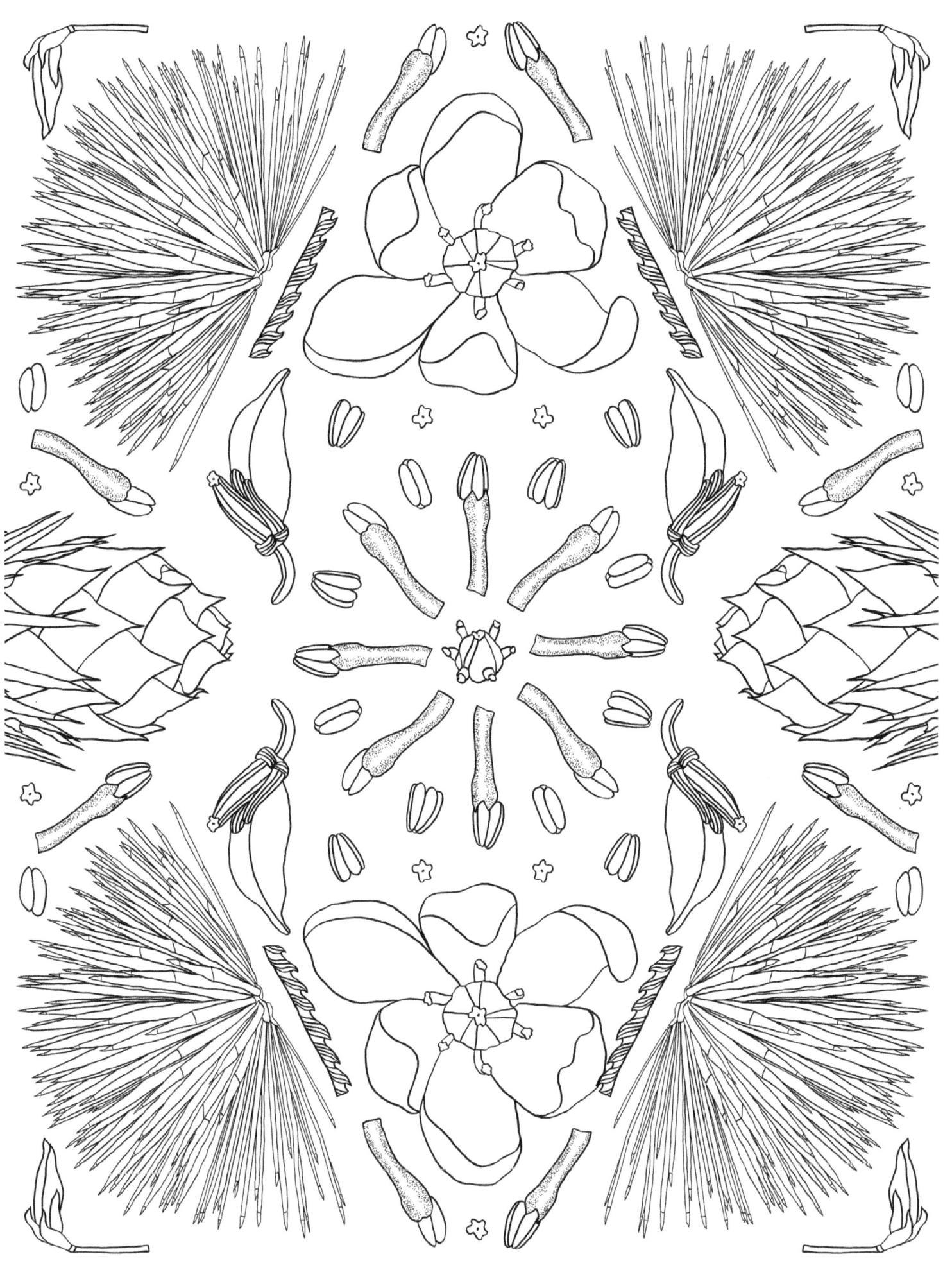

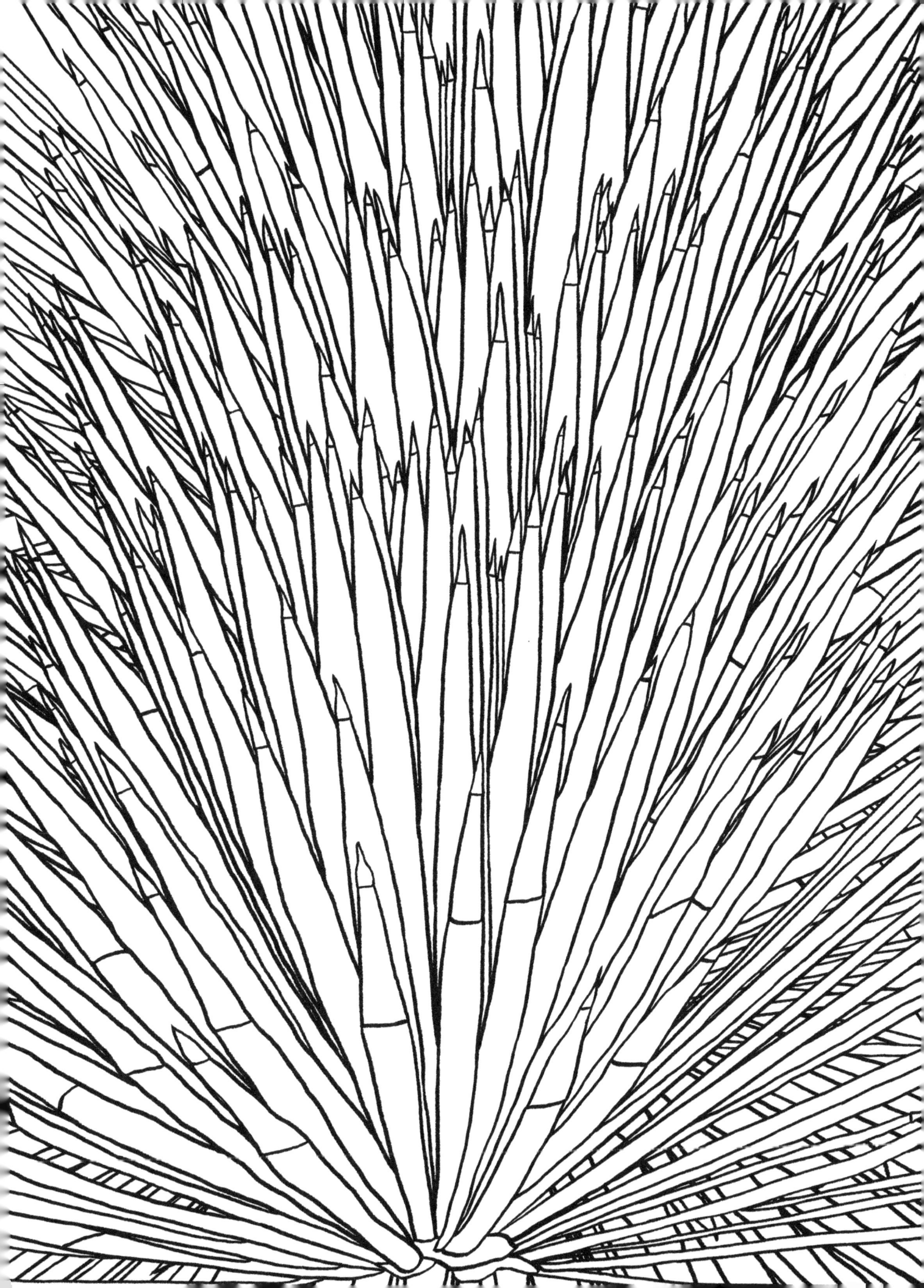

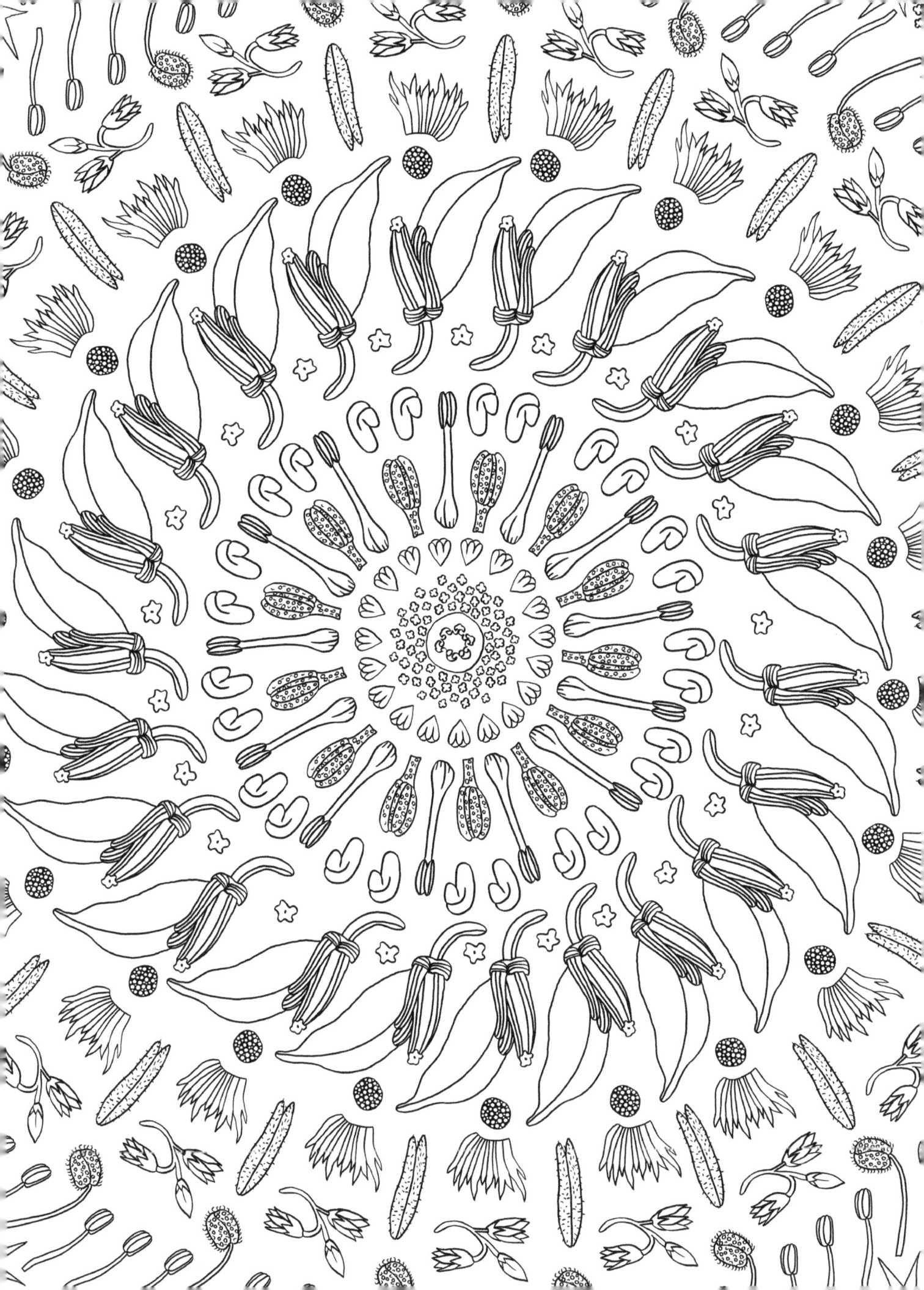

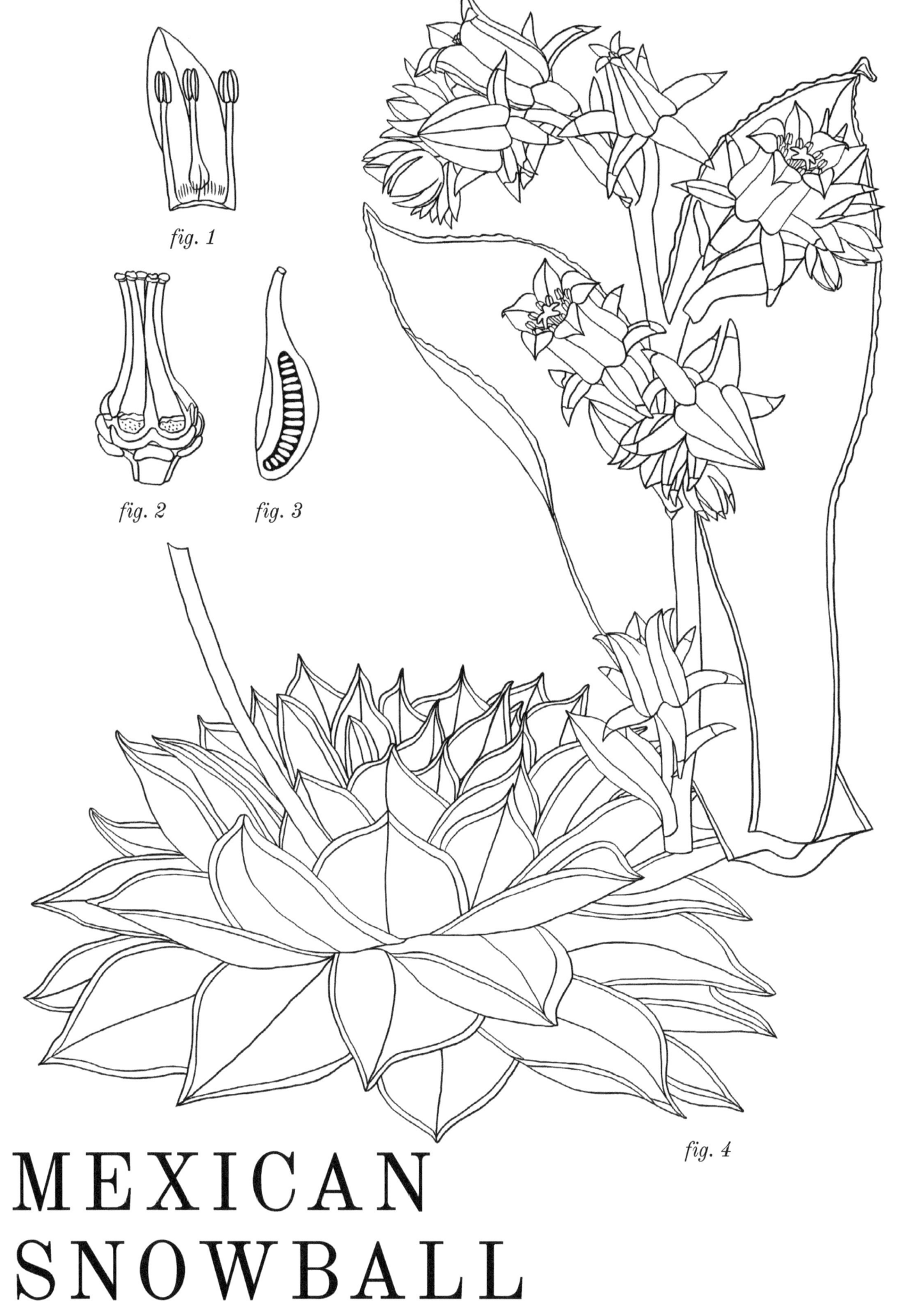

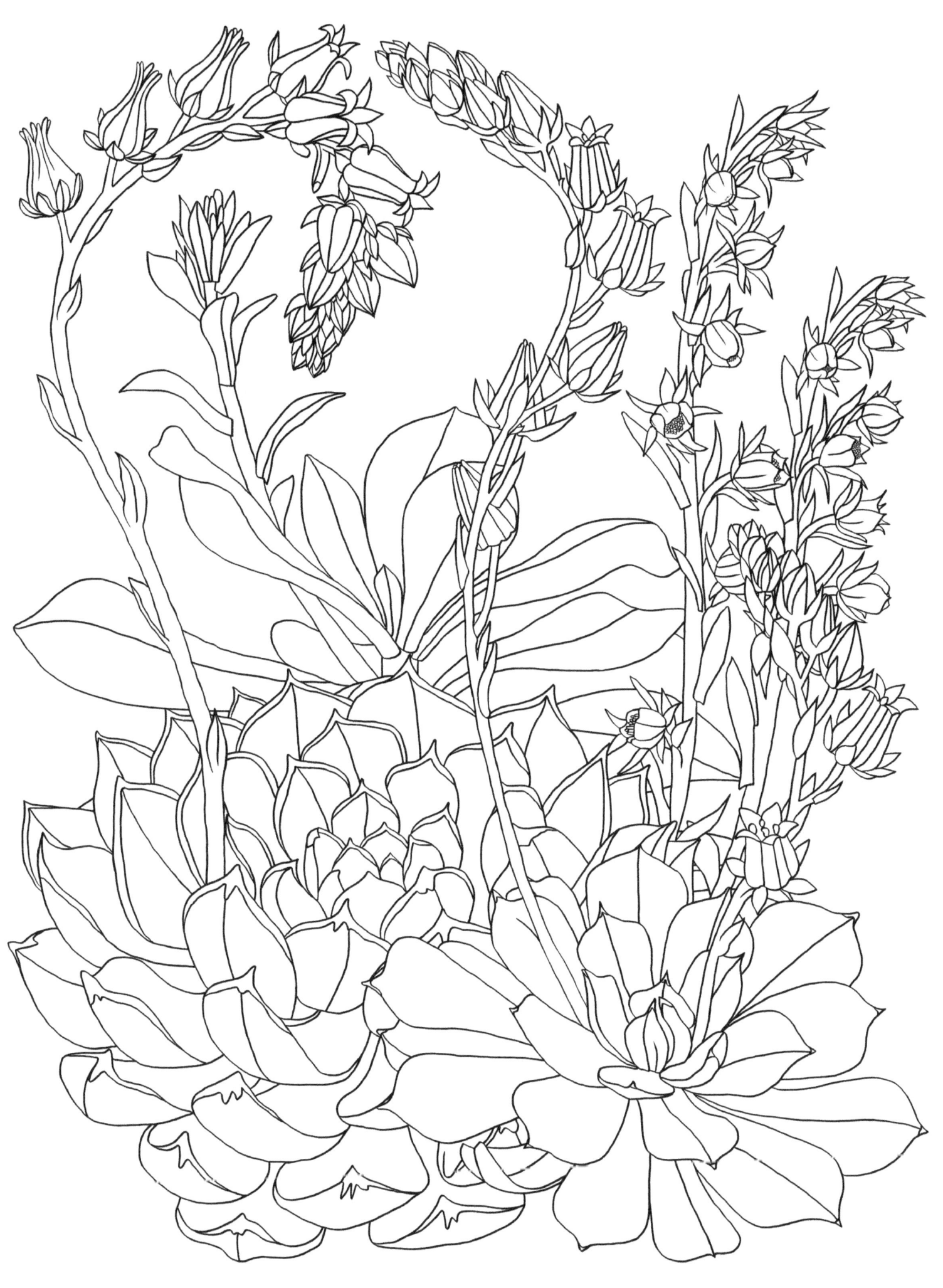

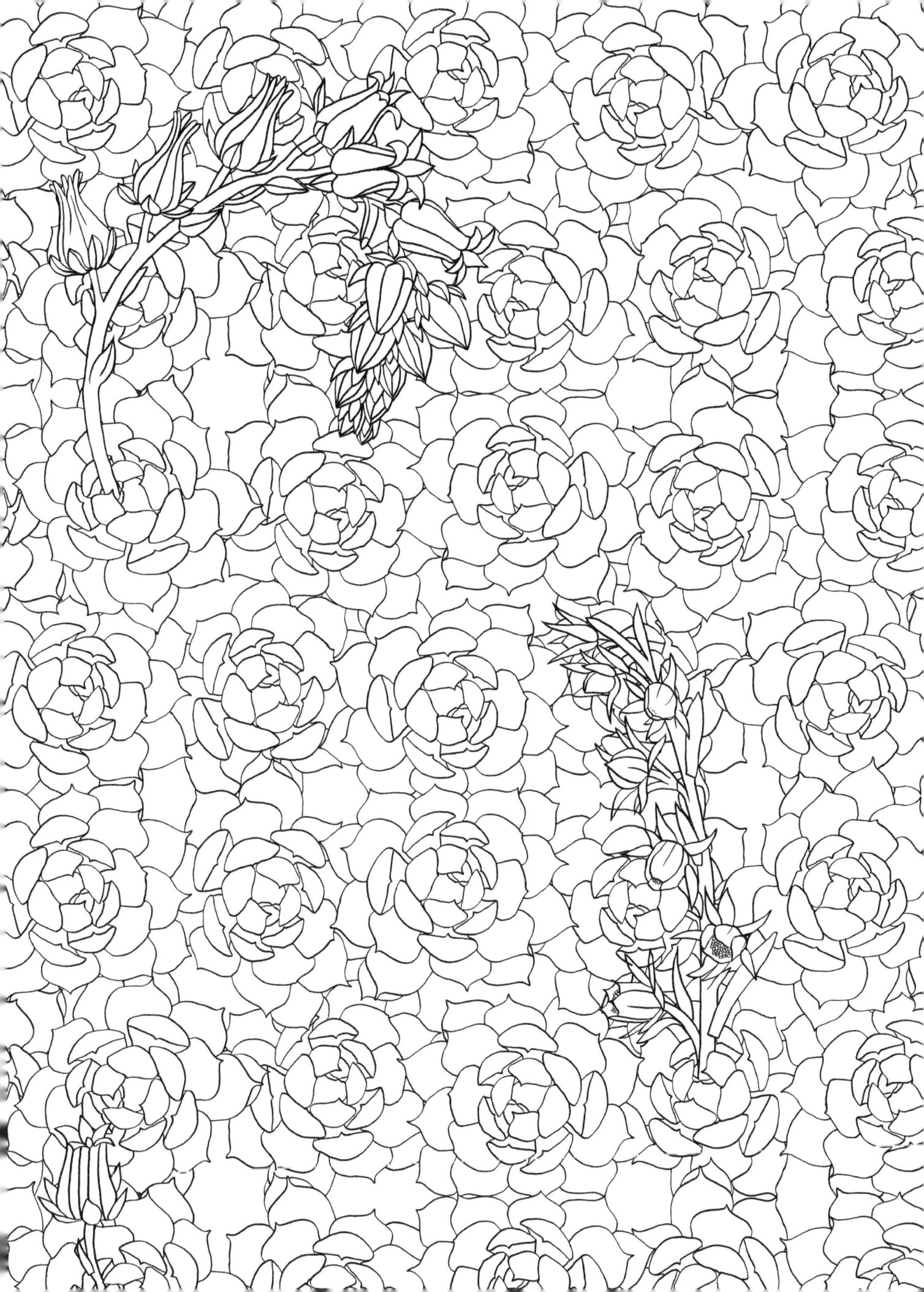

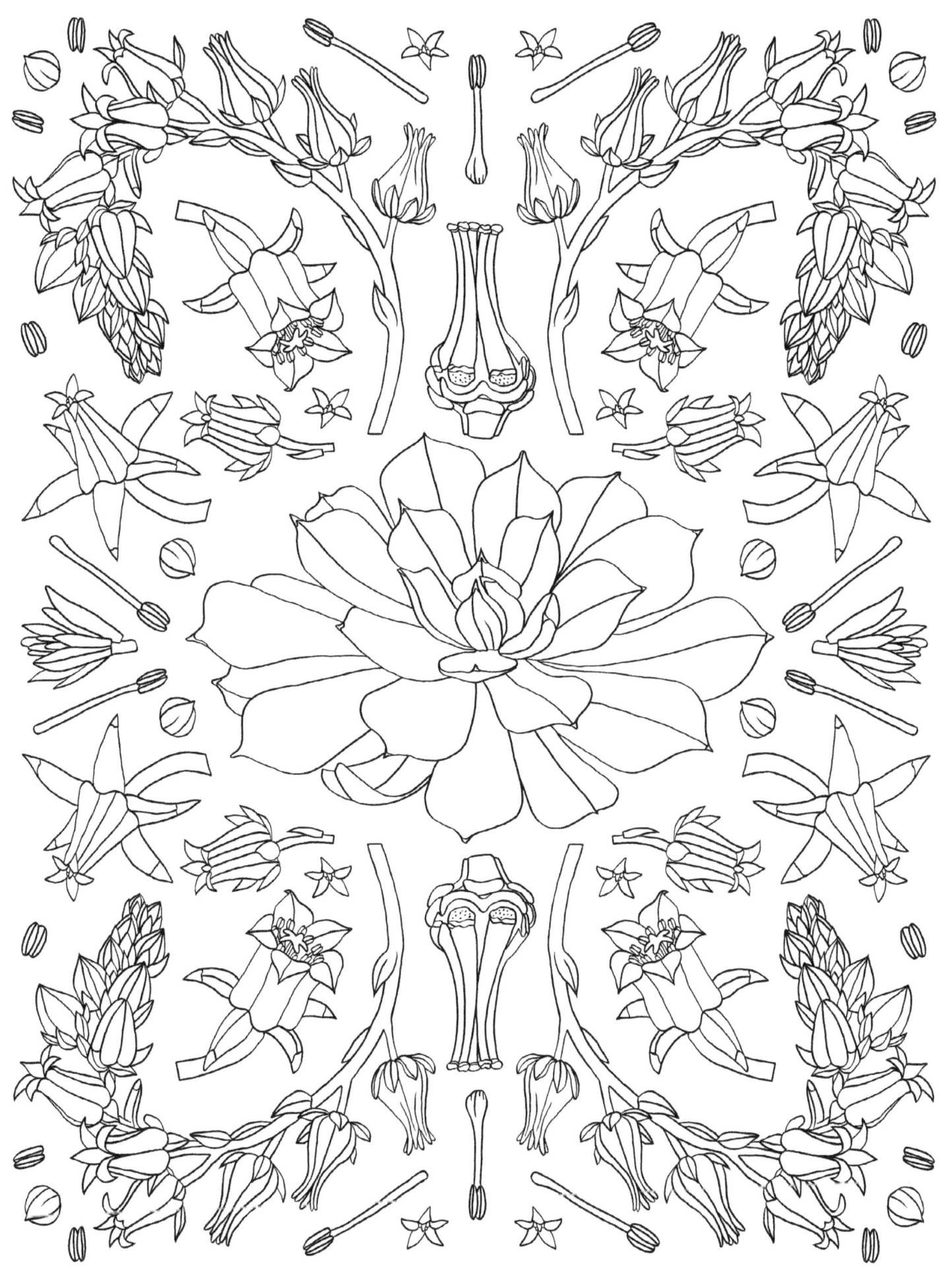

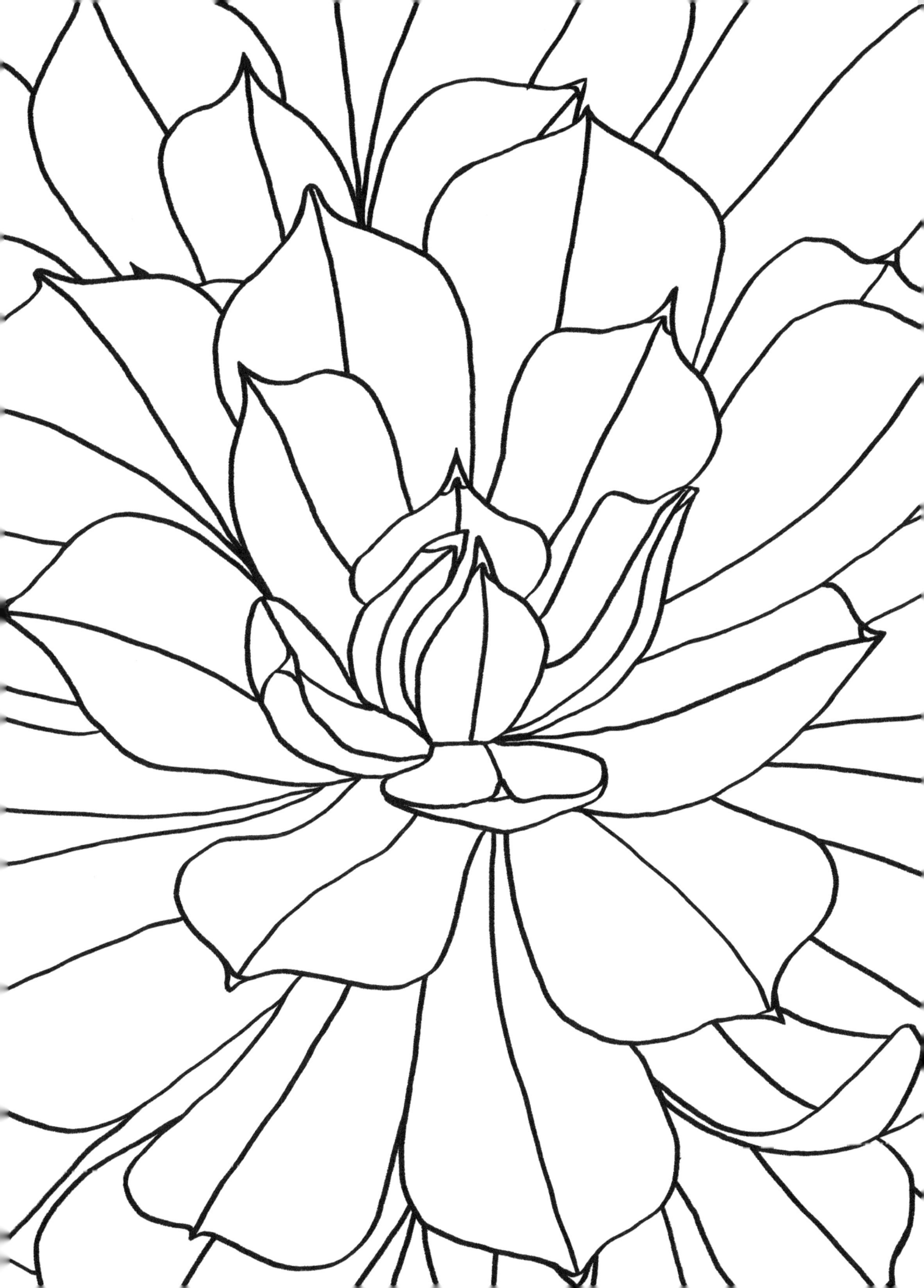

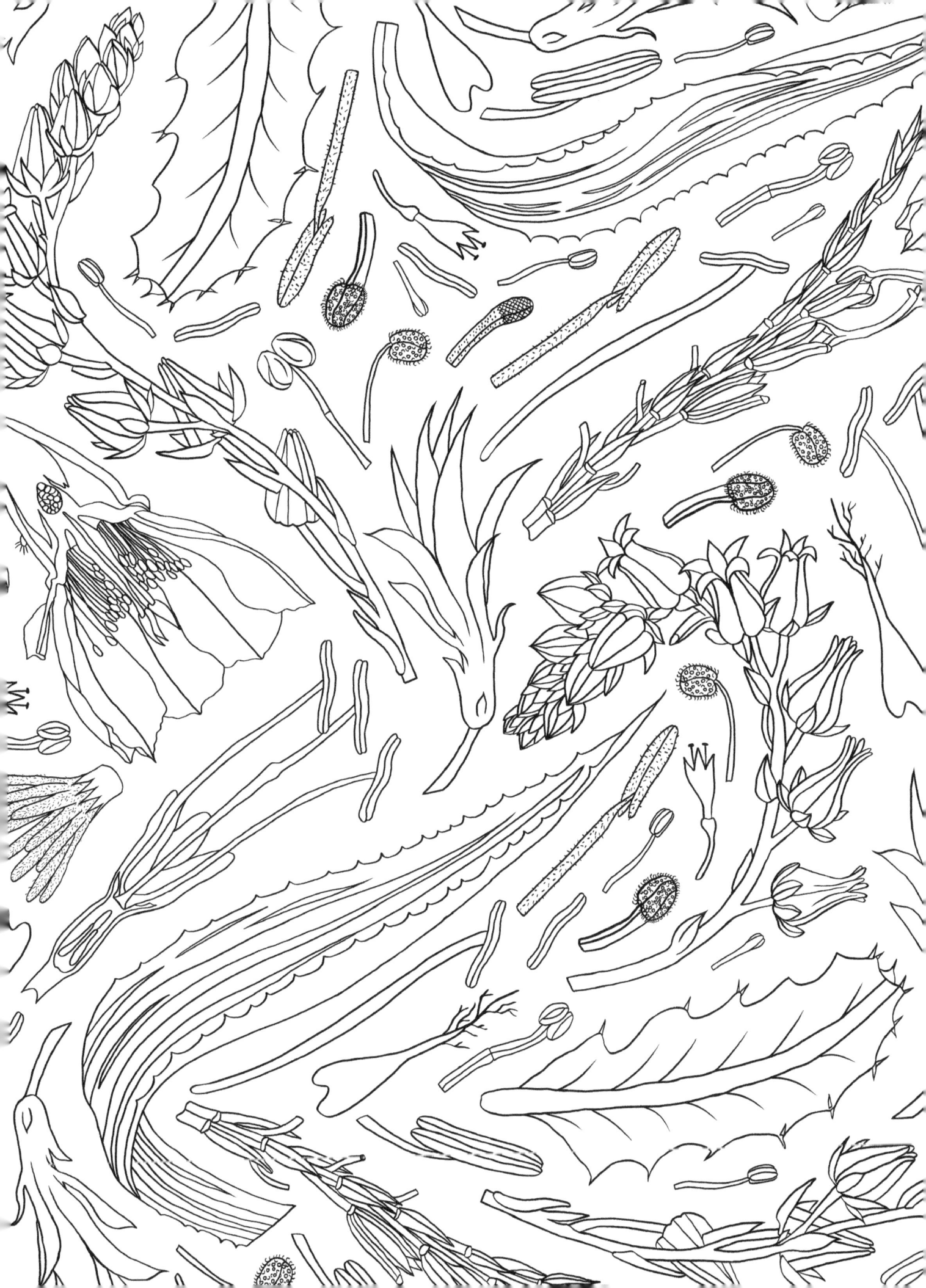

PINCUSHION

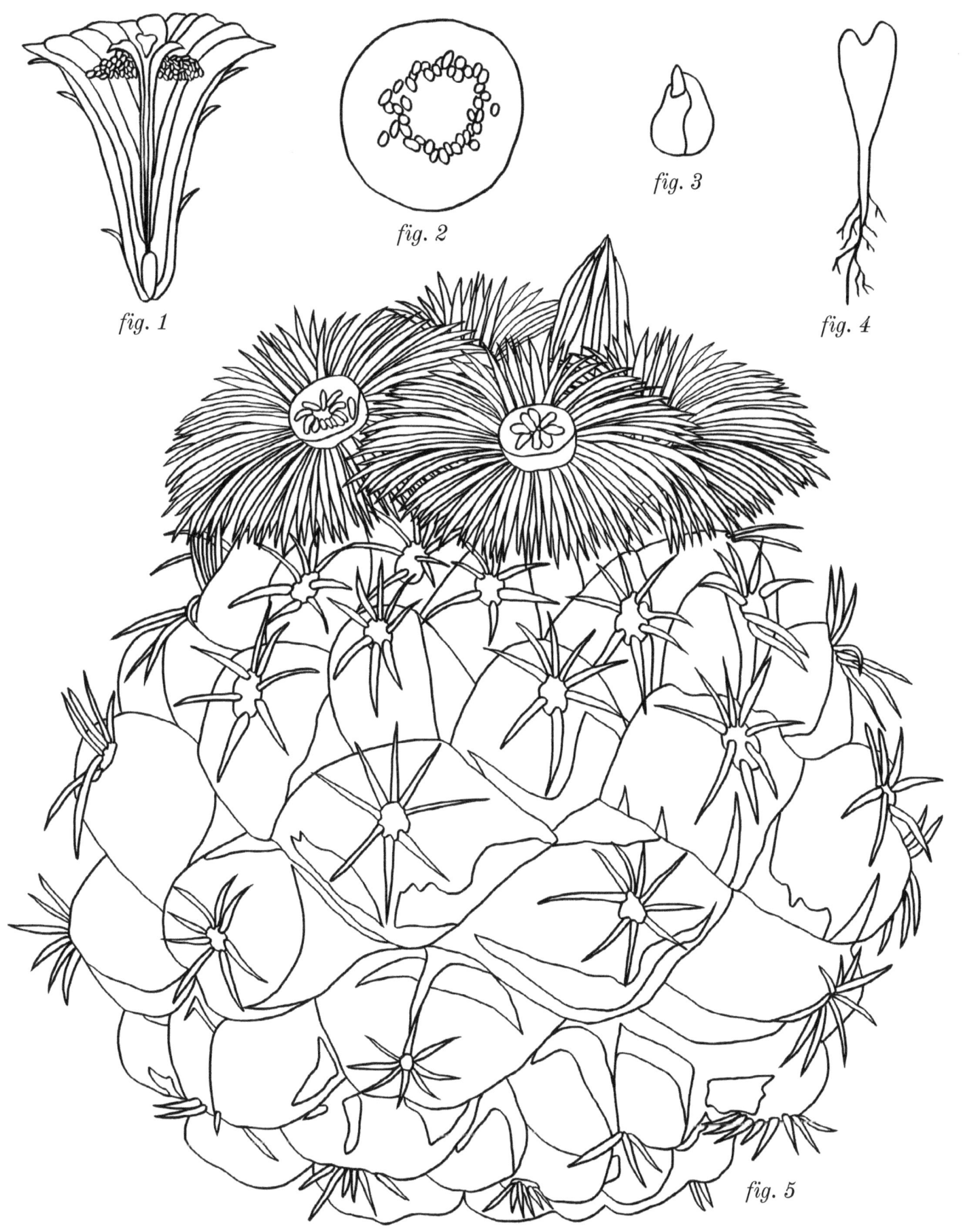

fig. 1
fig. 2
fig. 3
fig. 4
fig. 5

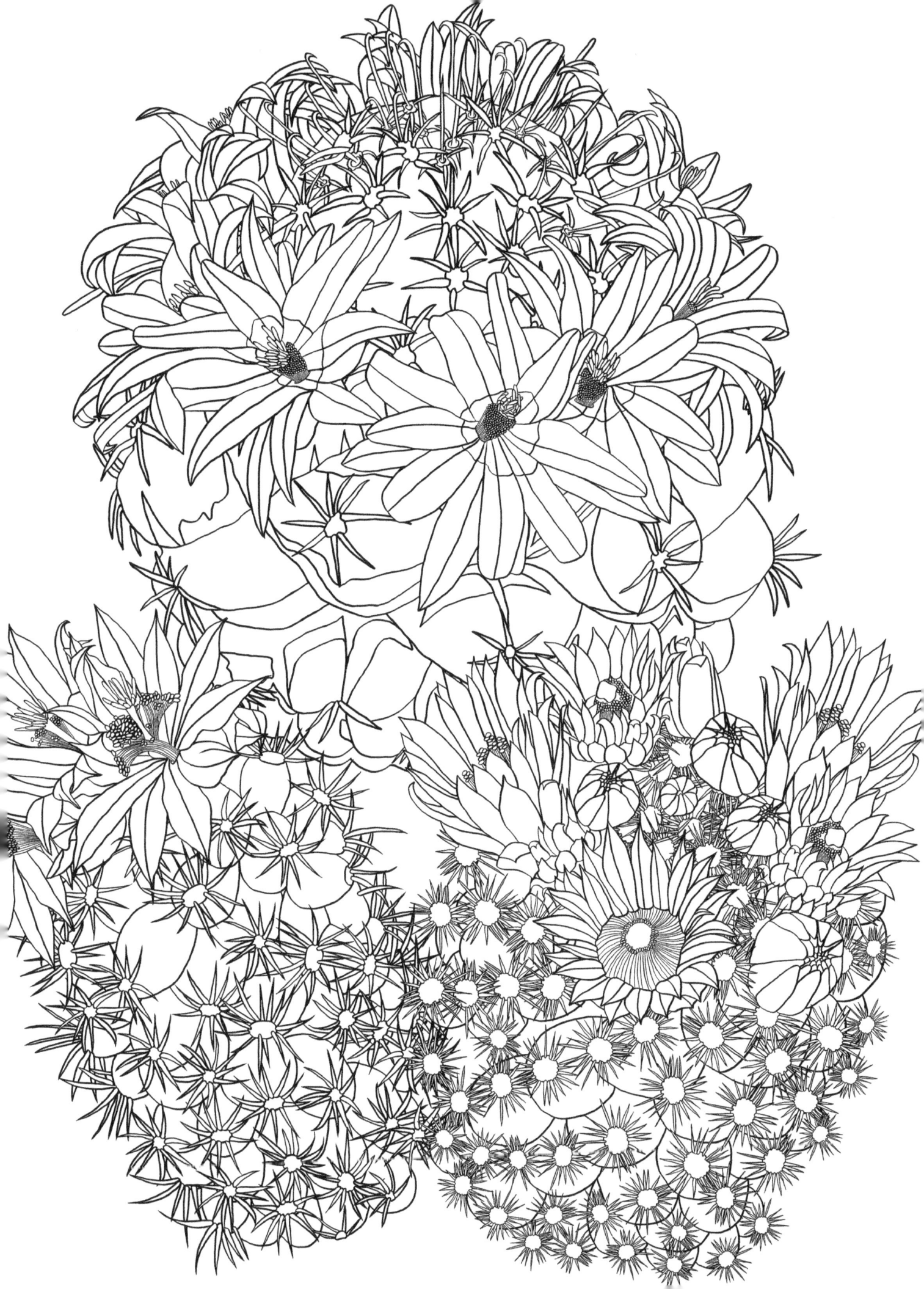

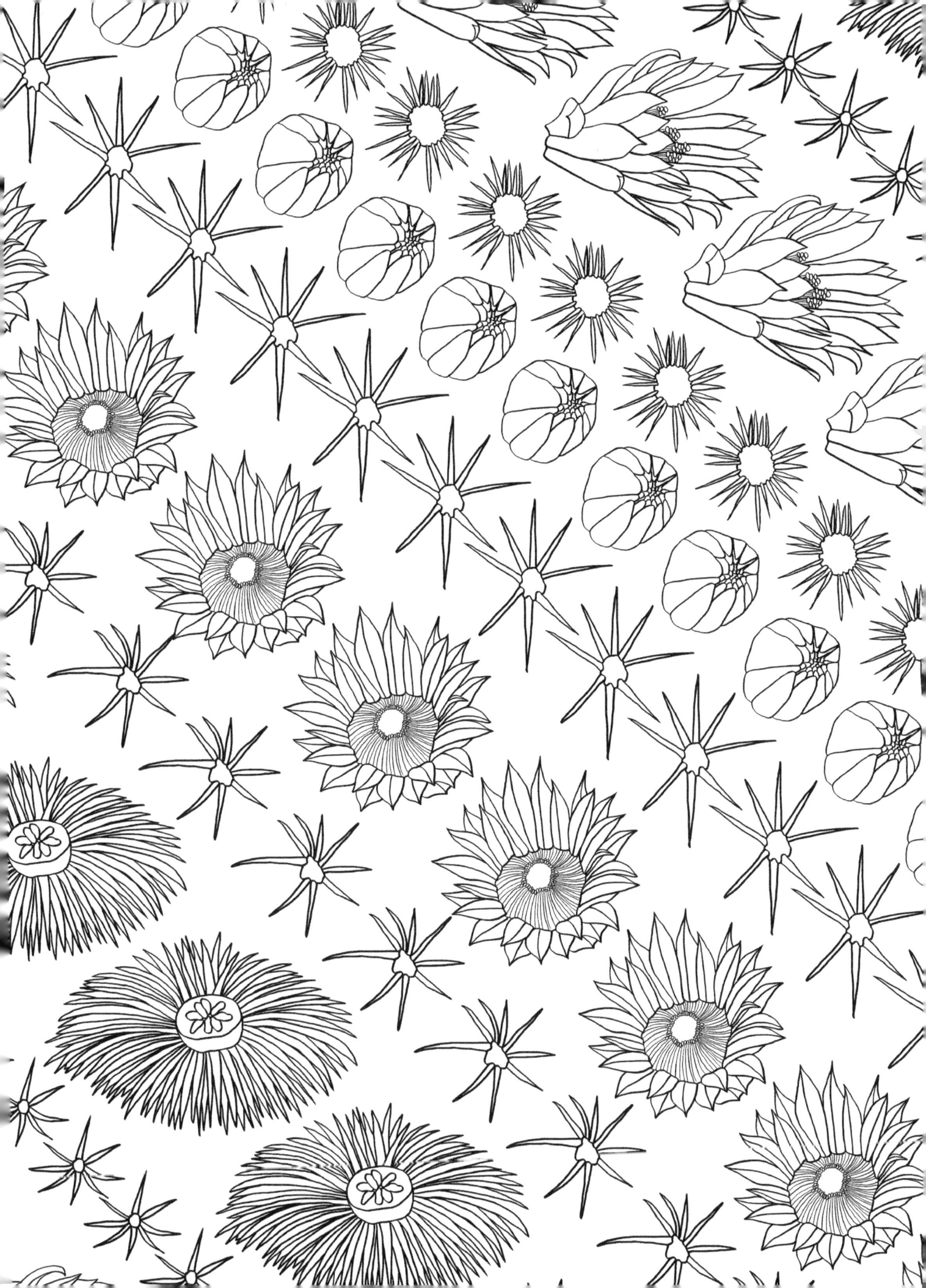

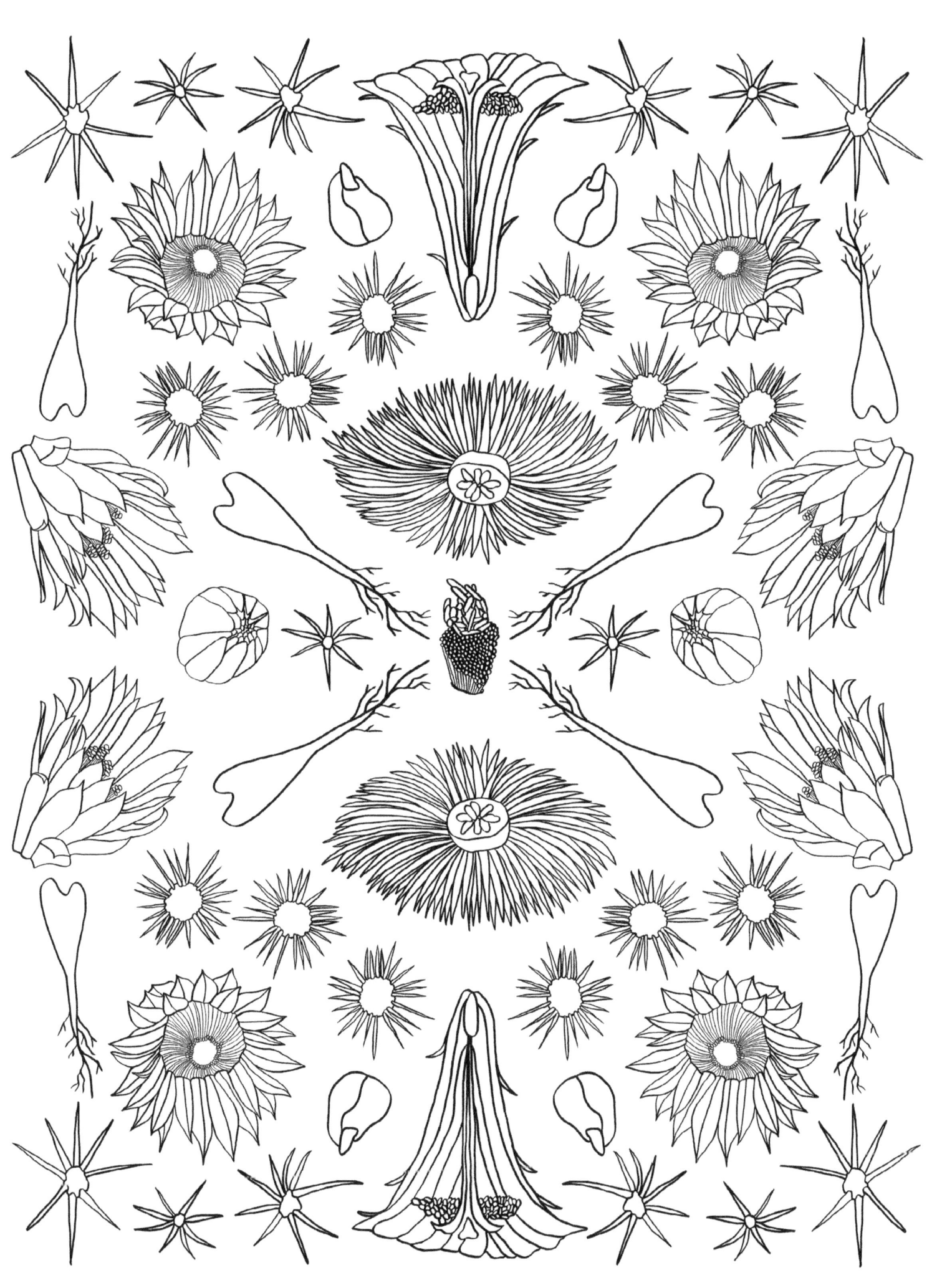

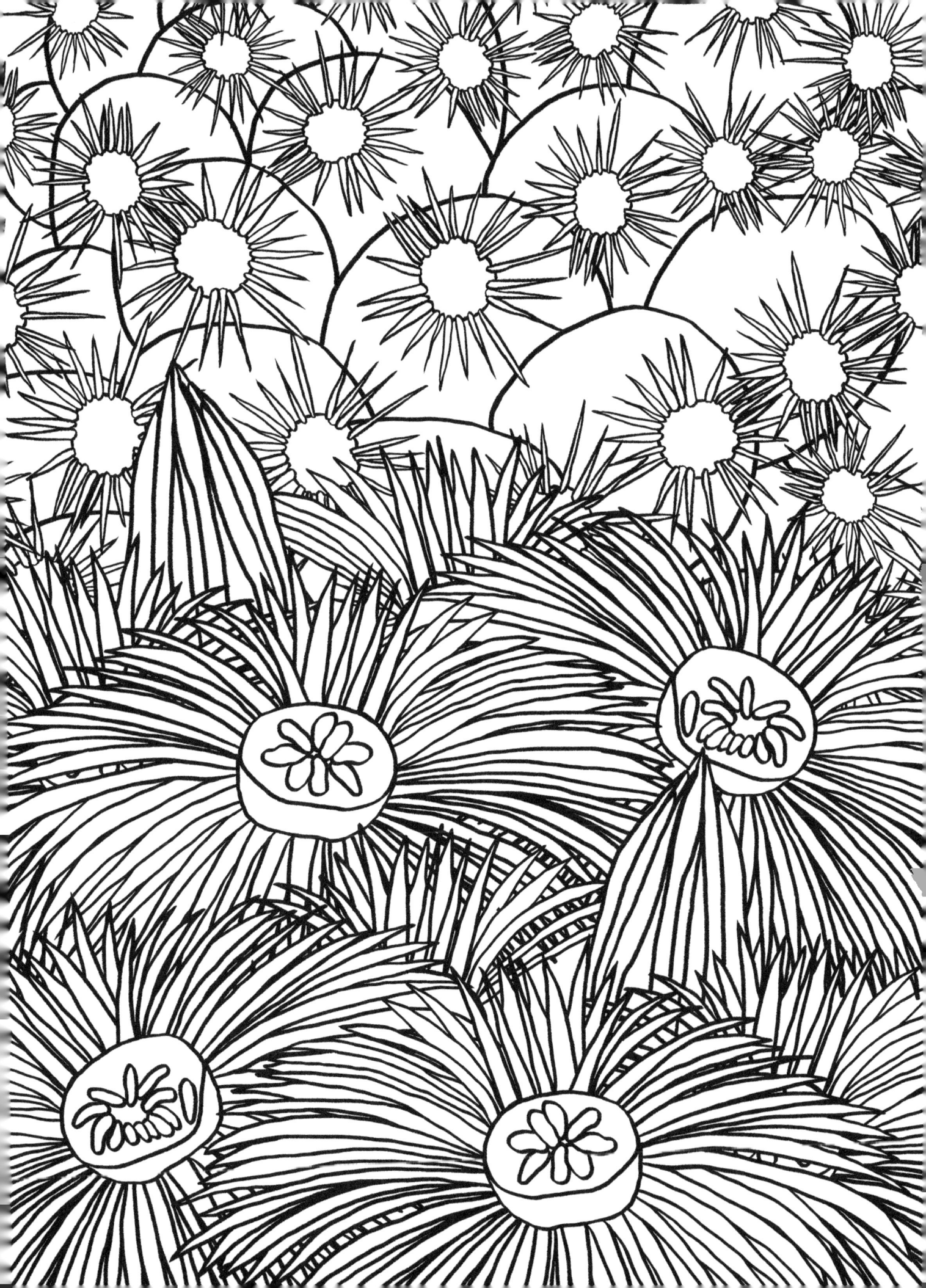

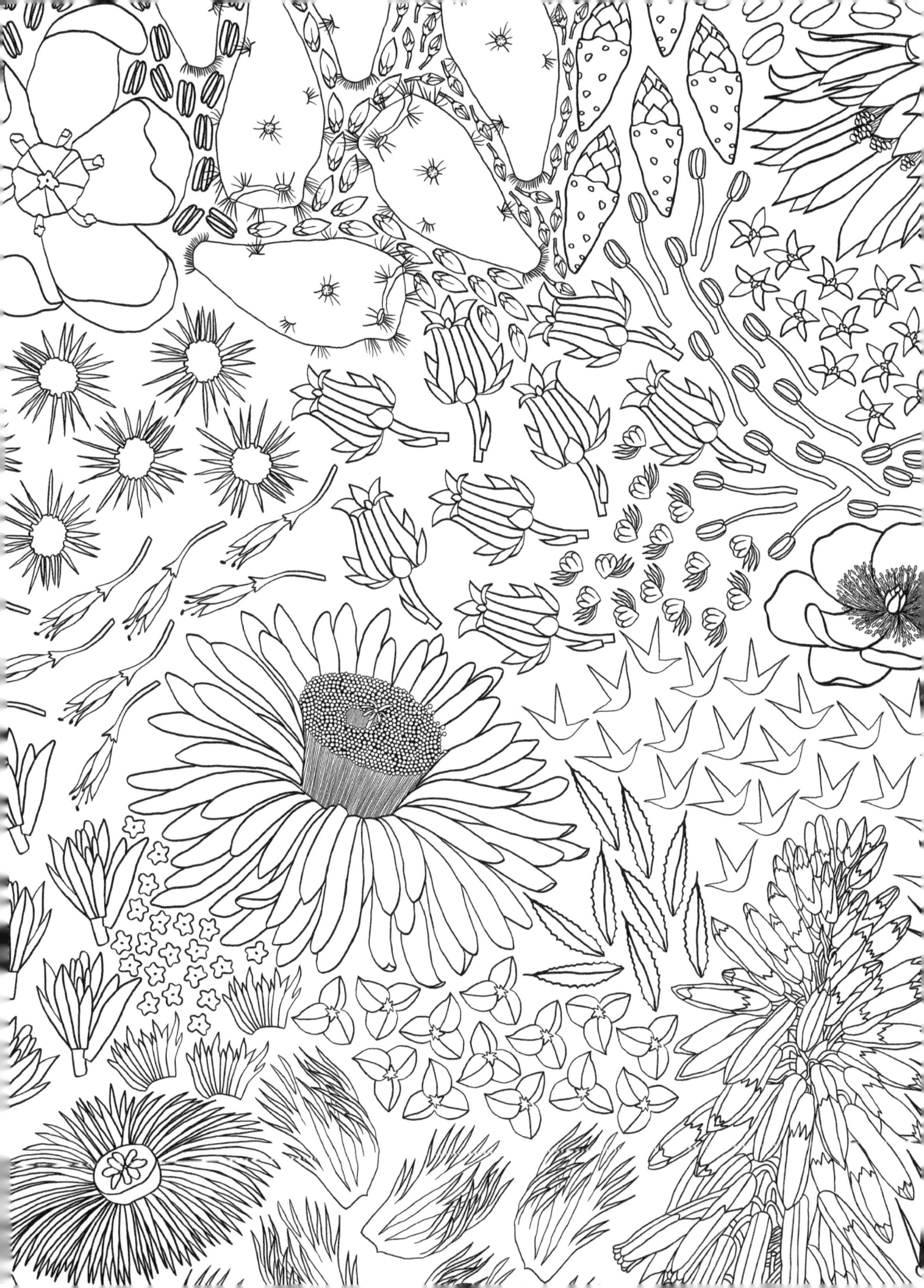

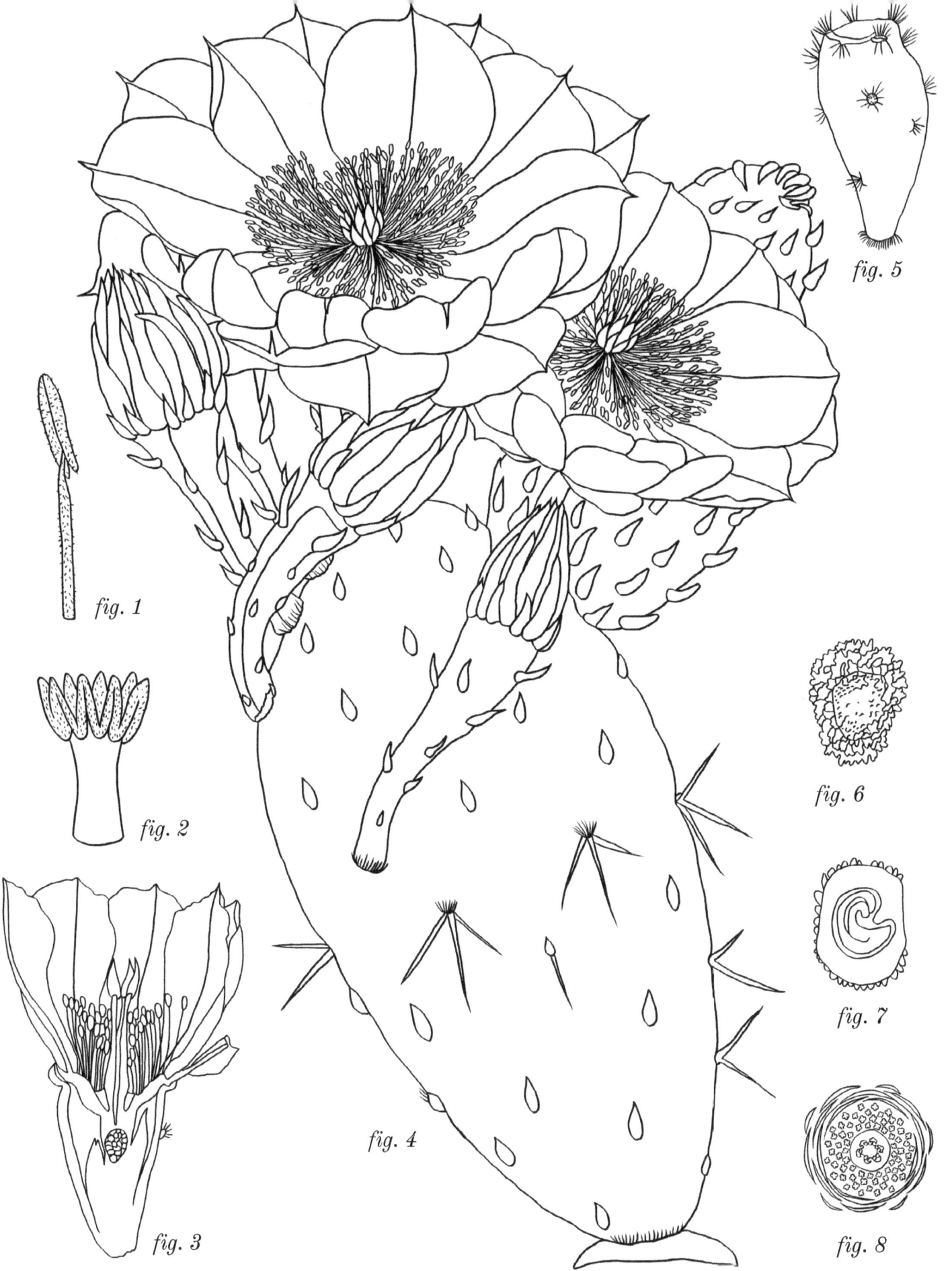

PRICKLY PEAR

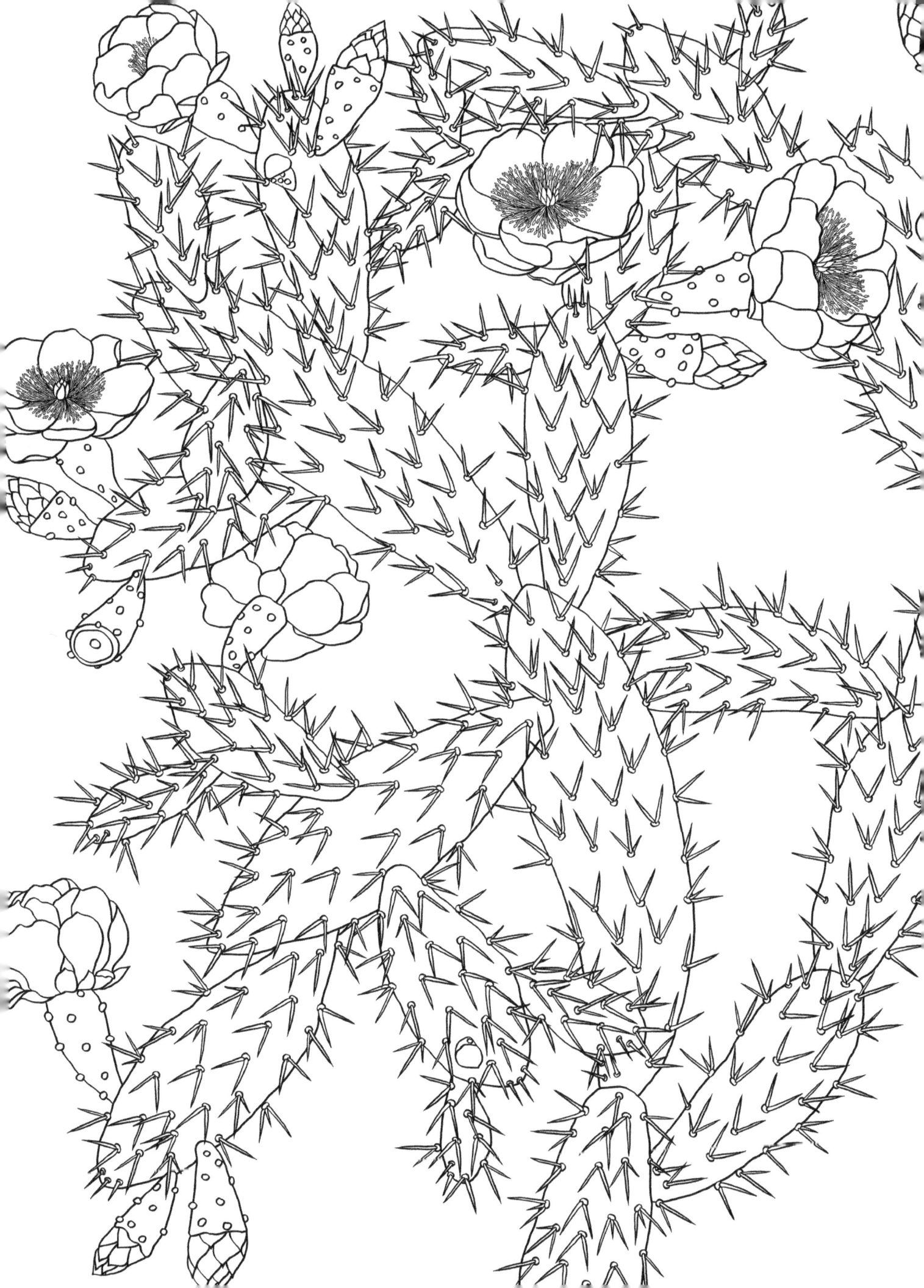

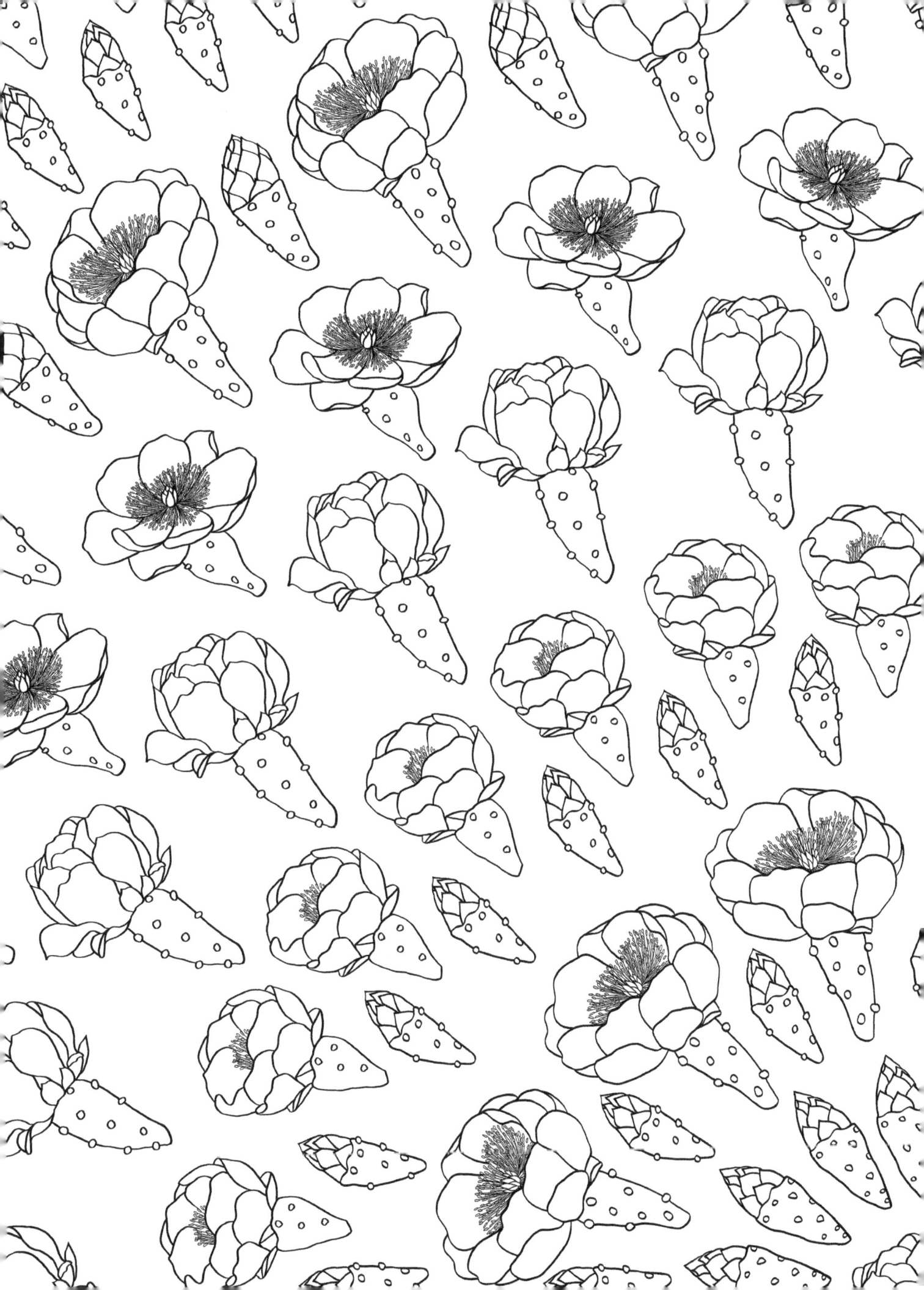

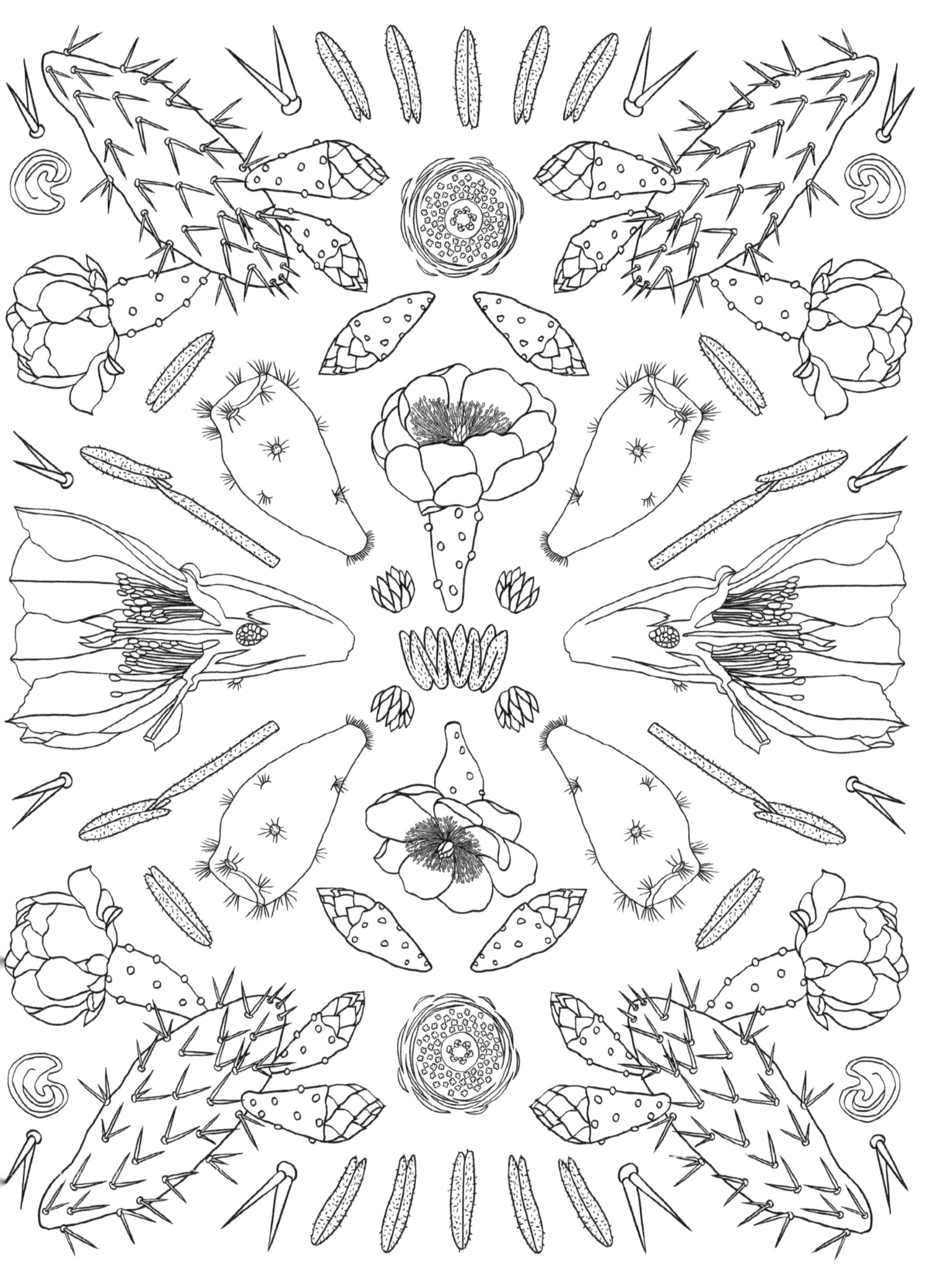

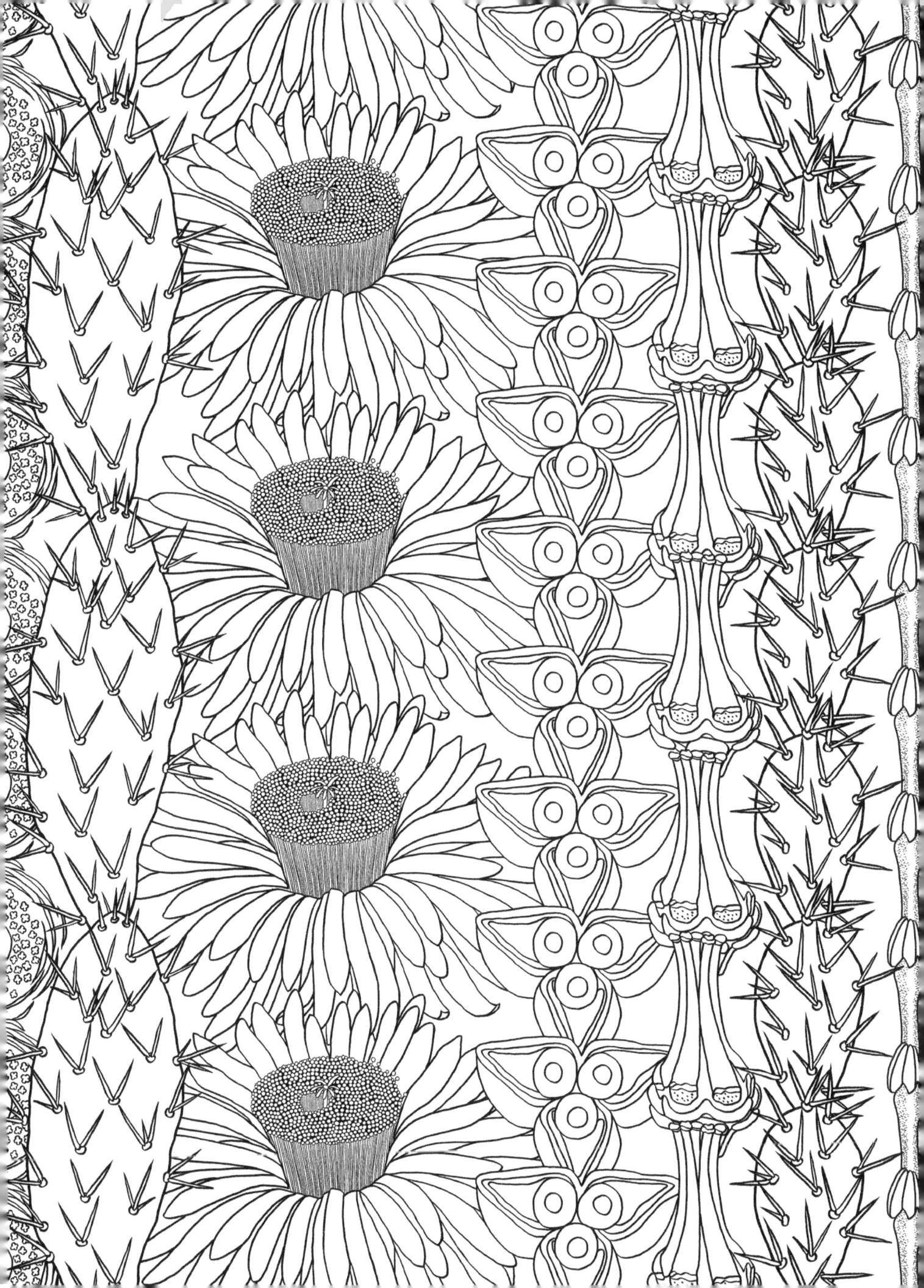

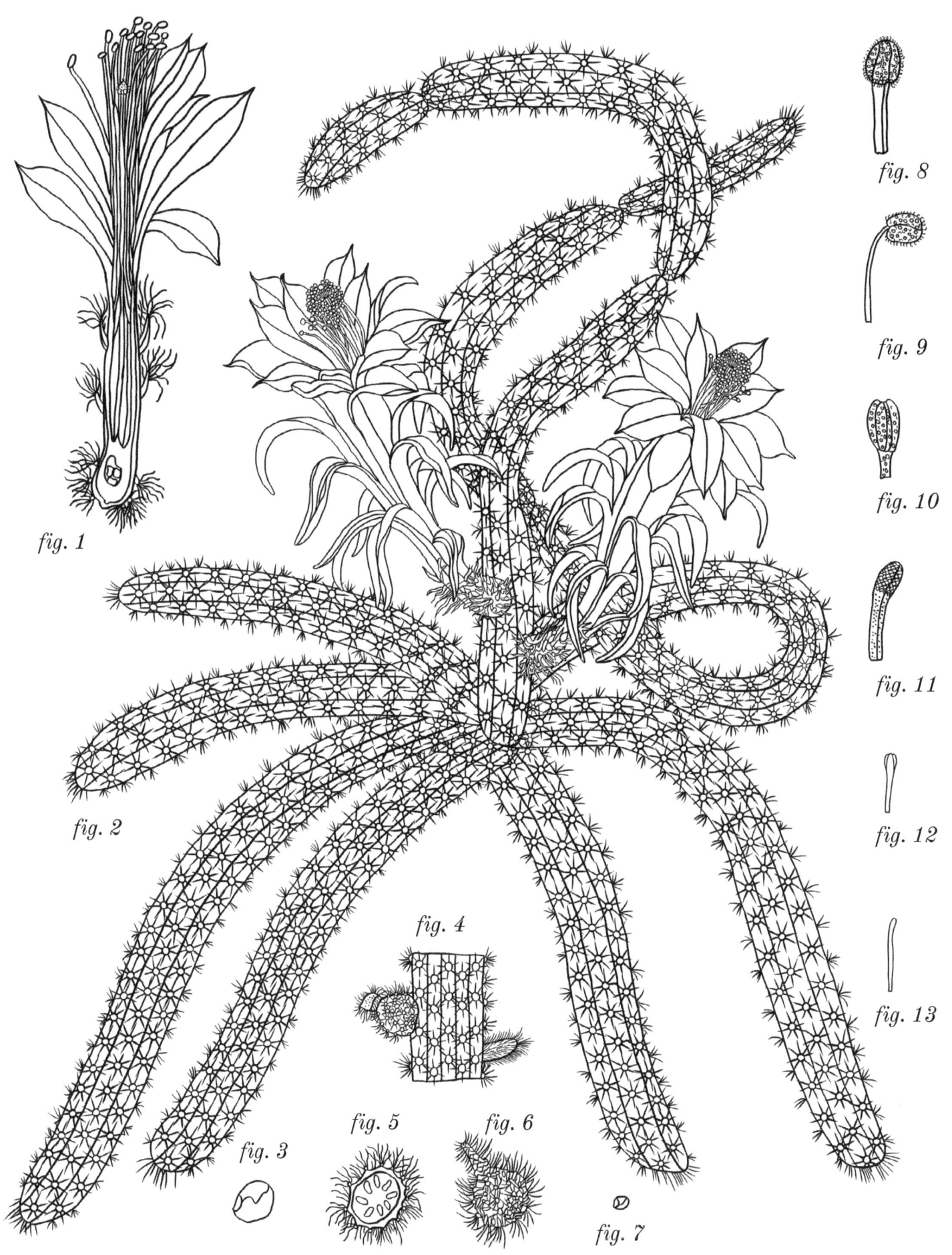

RAT TAIL CACTUS

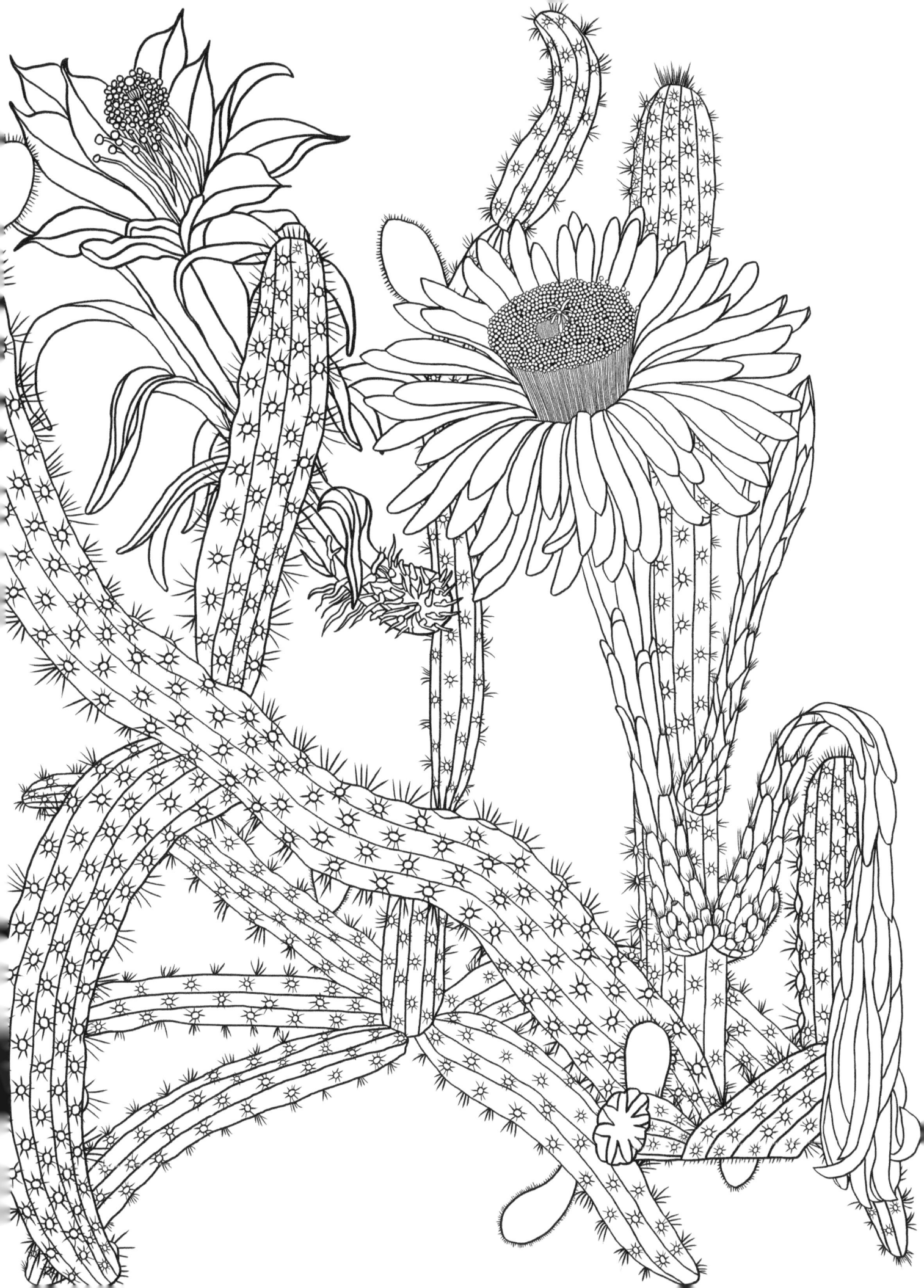

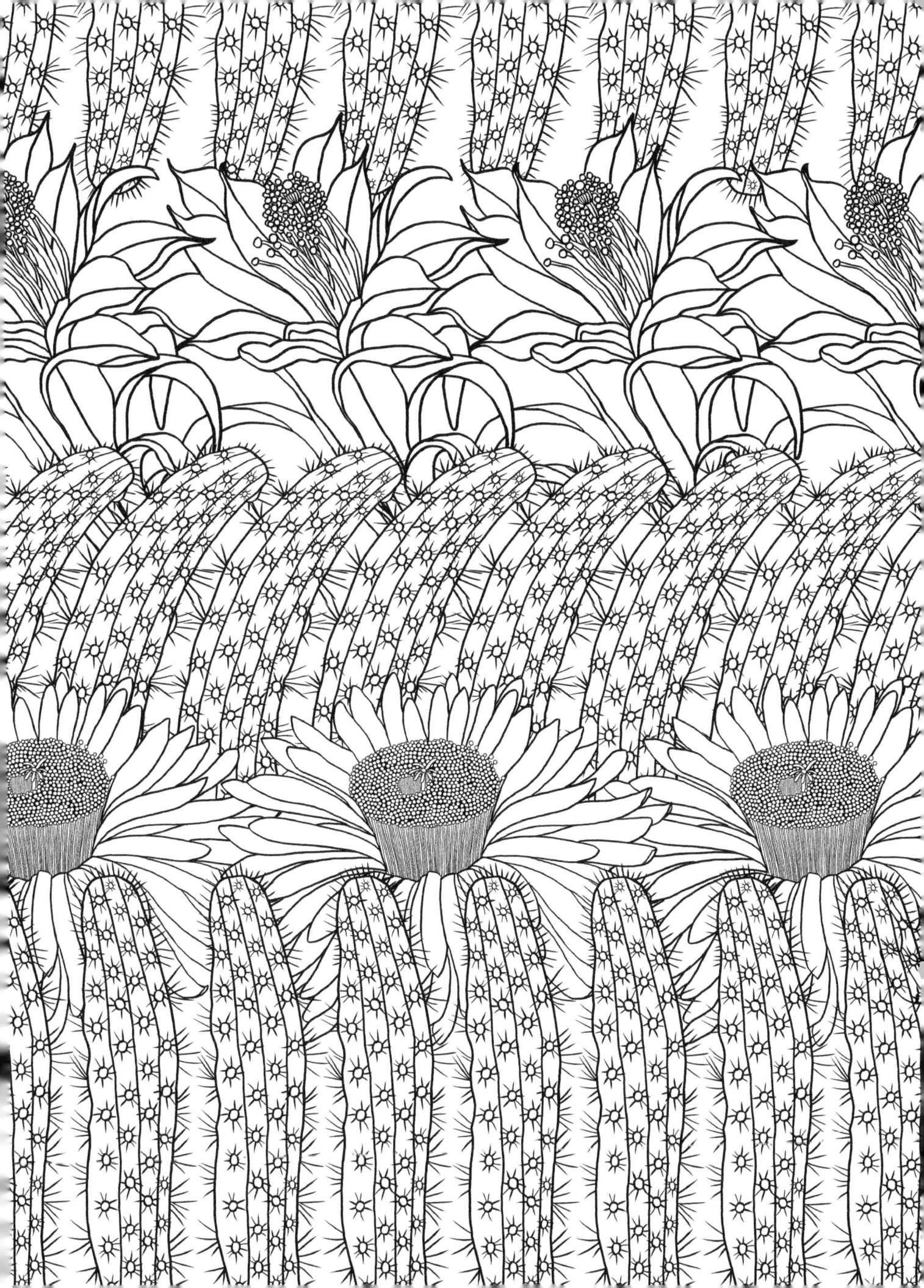

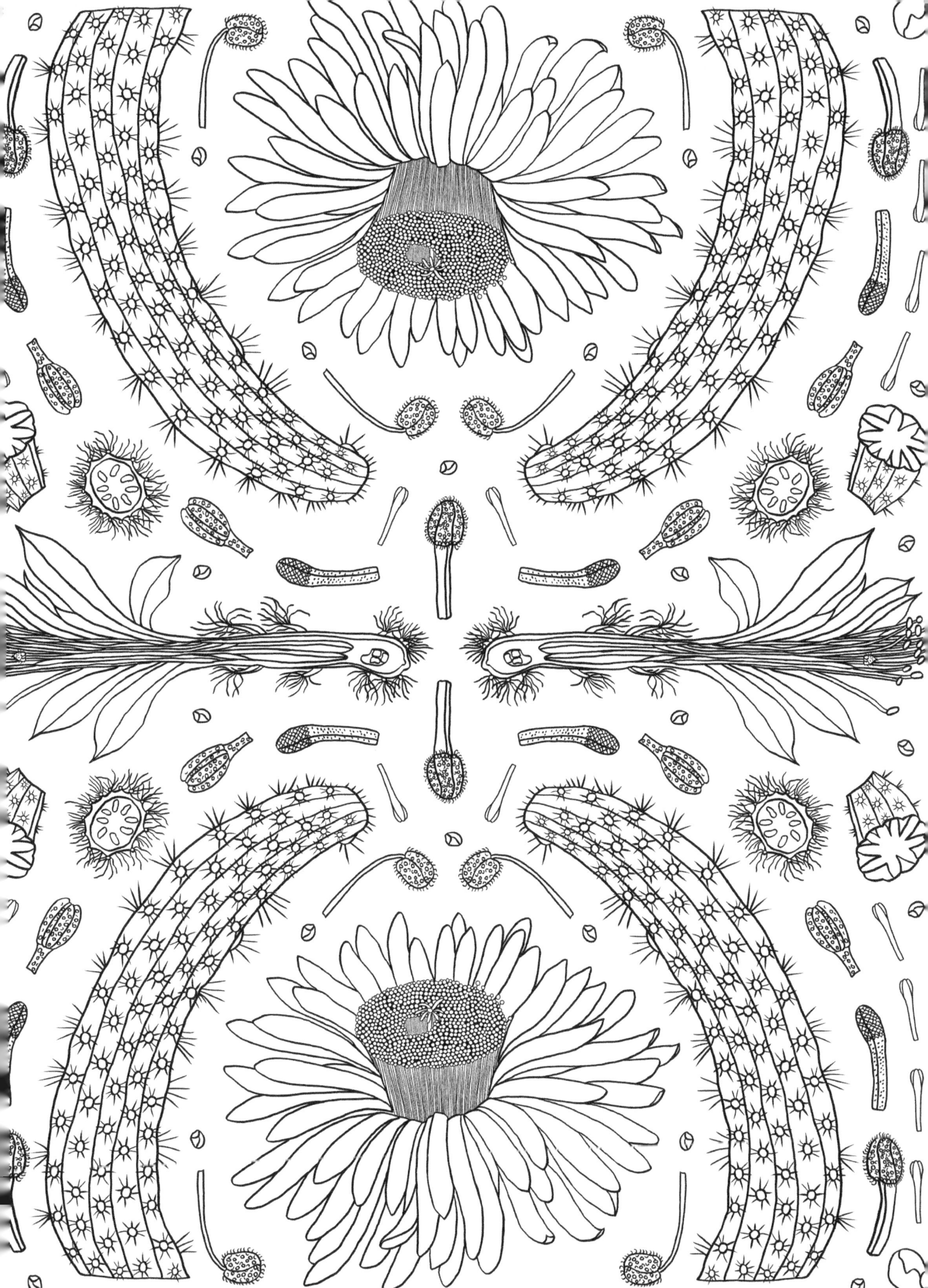

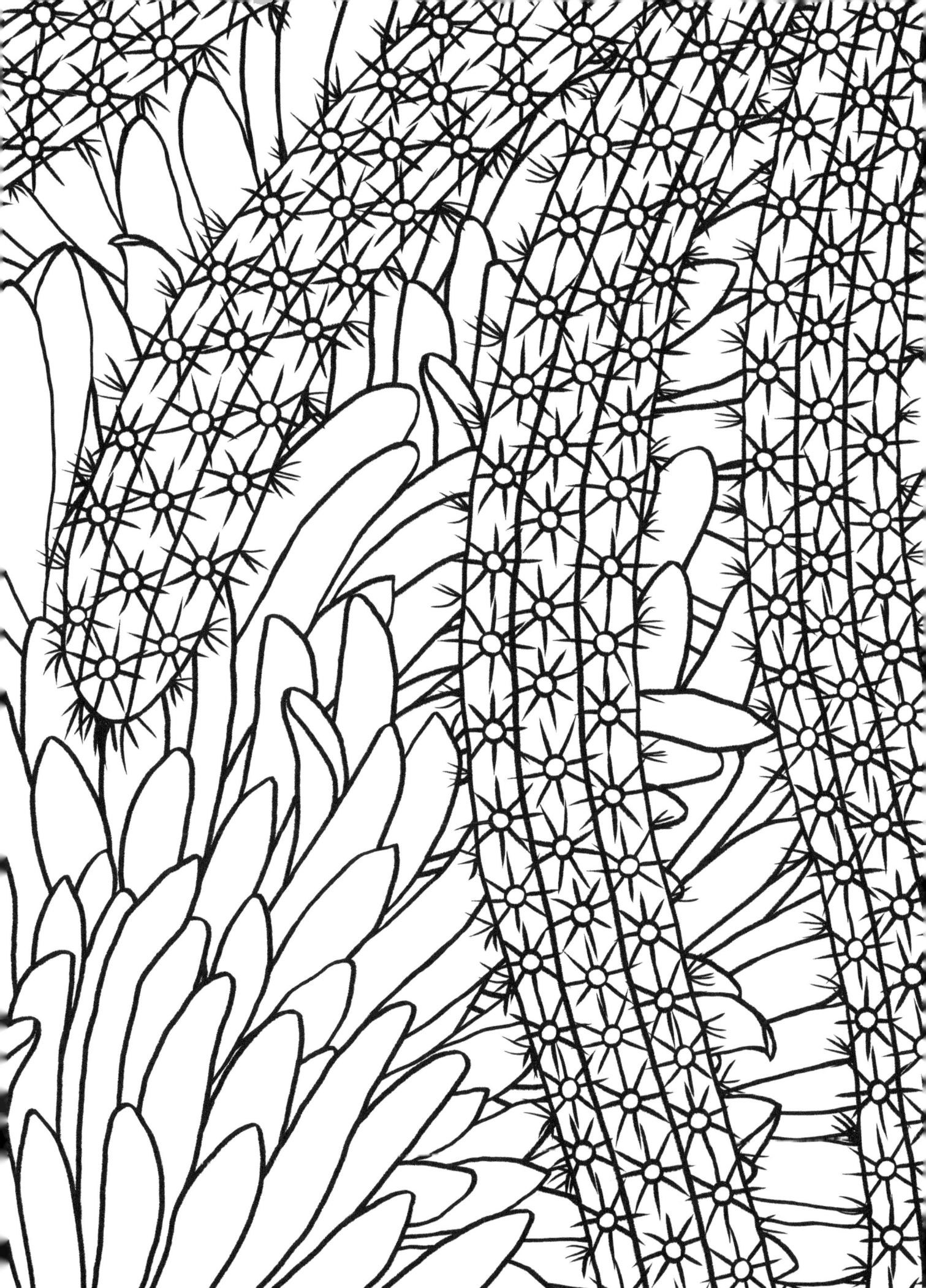

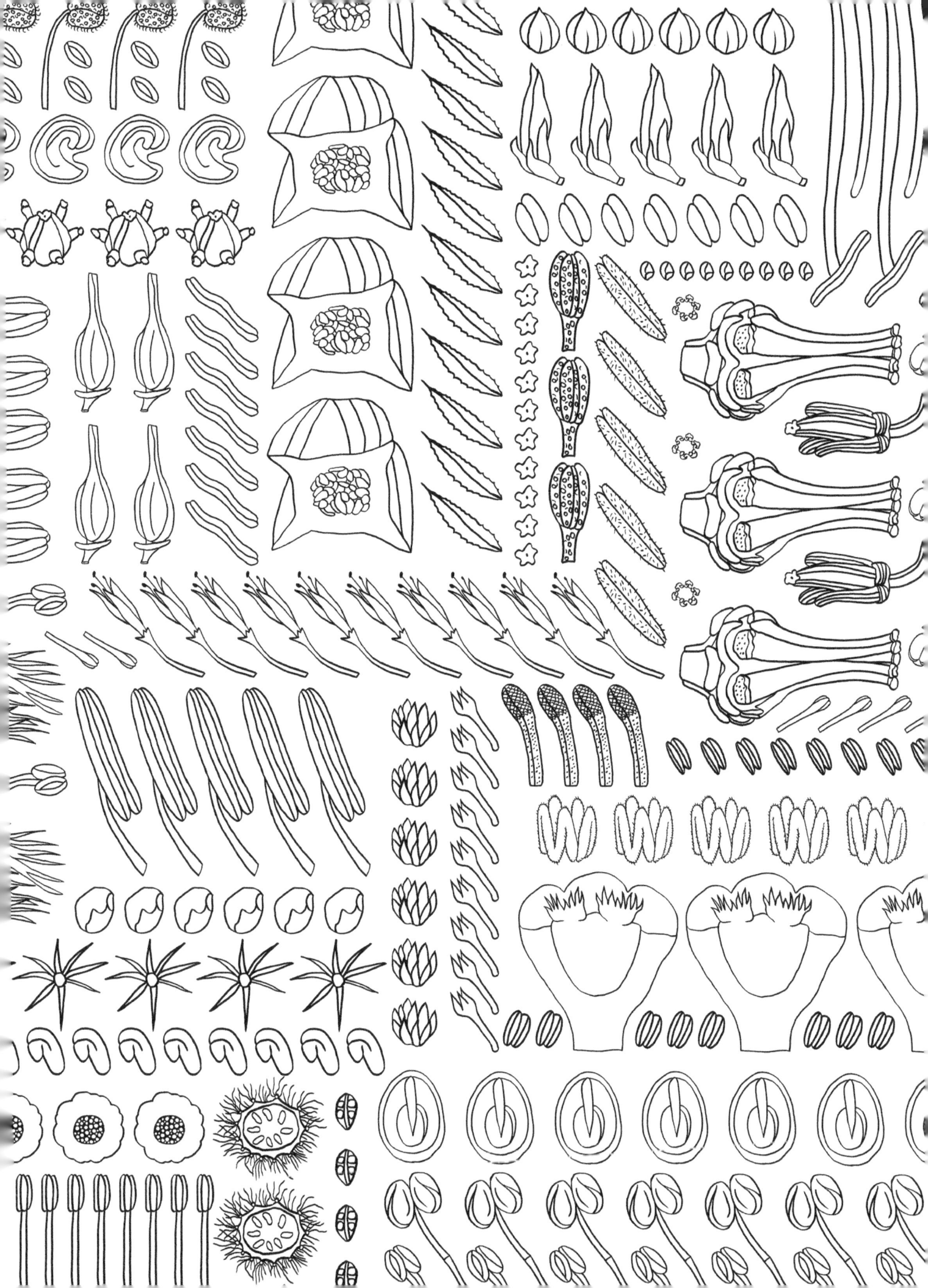

SAGUARO

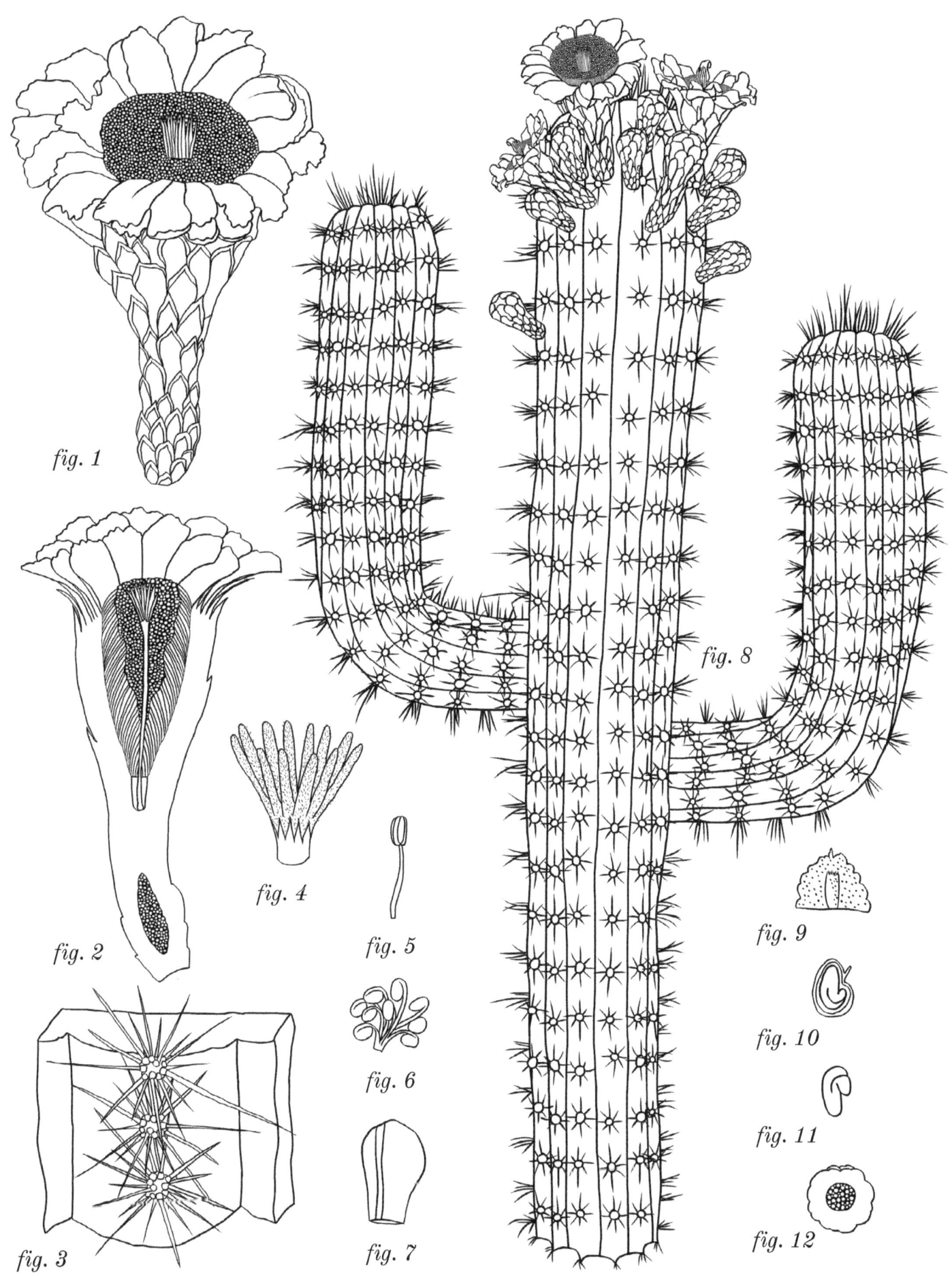

fig. 1
fig. 2
fig. 3
fig. 4
fig. 5
fig. 6
fig. 7
fig. 8
fig. 9
fig. 10
fig. 11
fig. 12

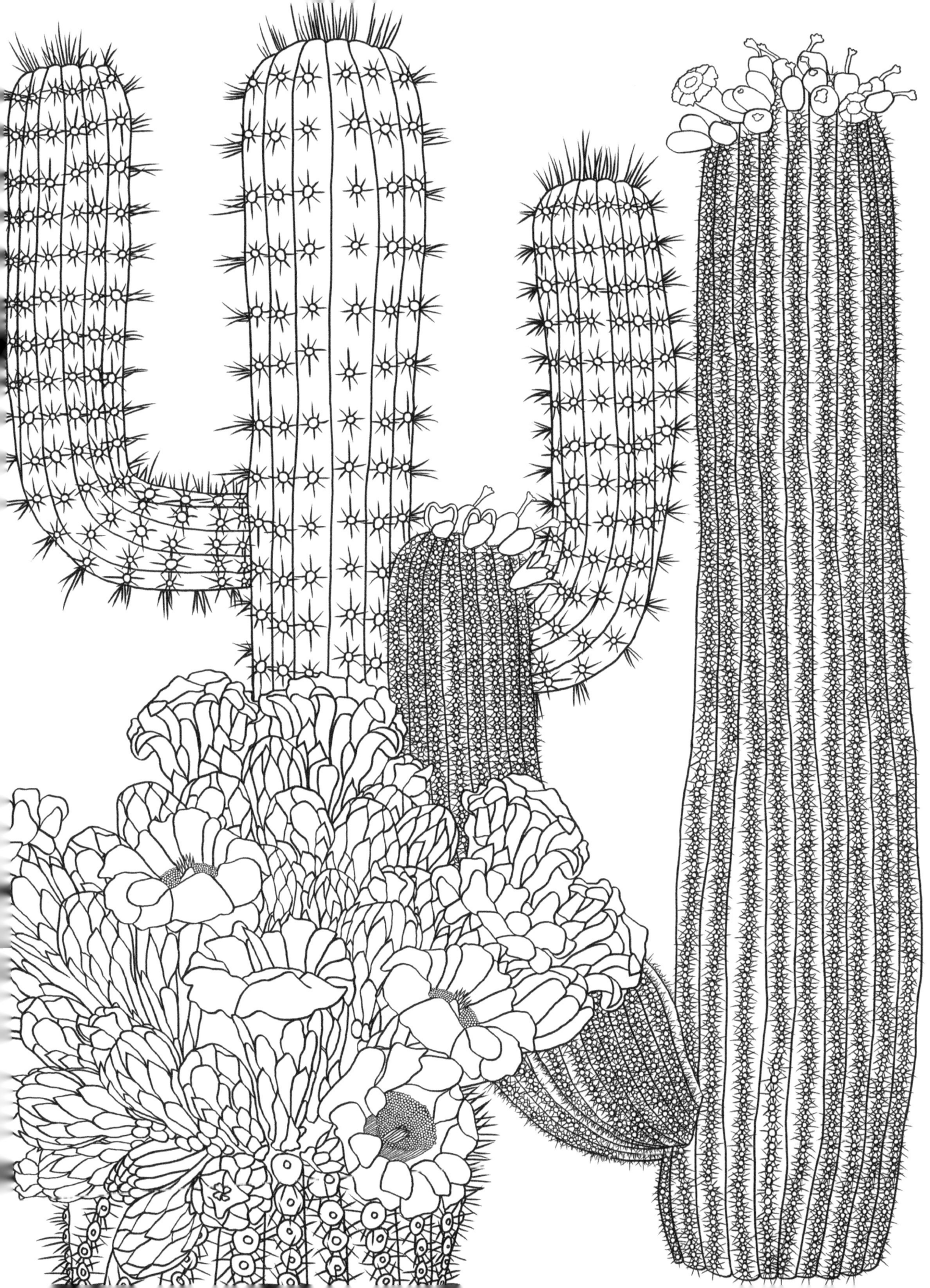

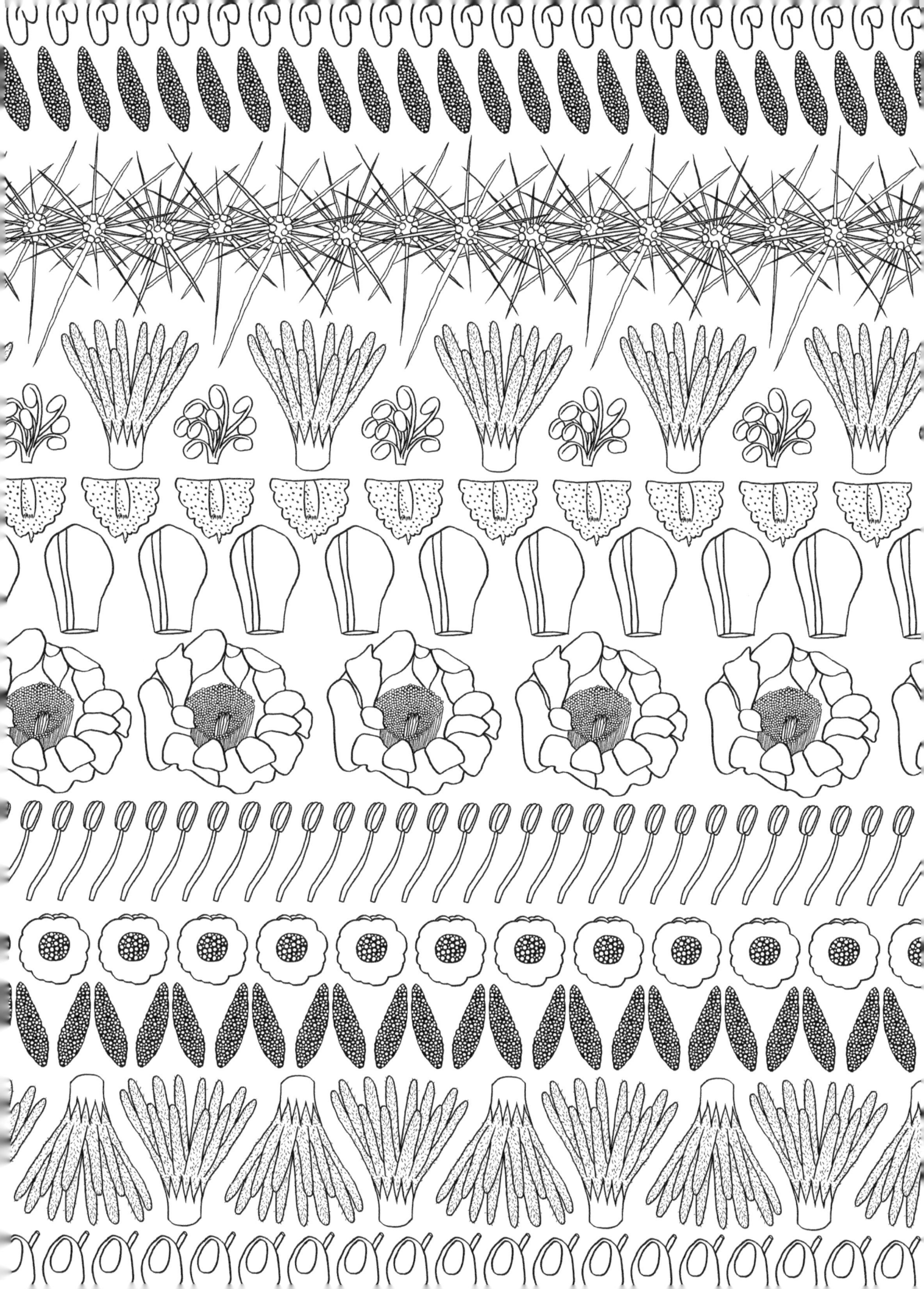

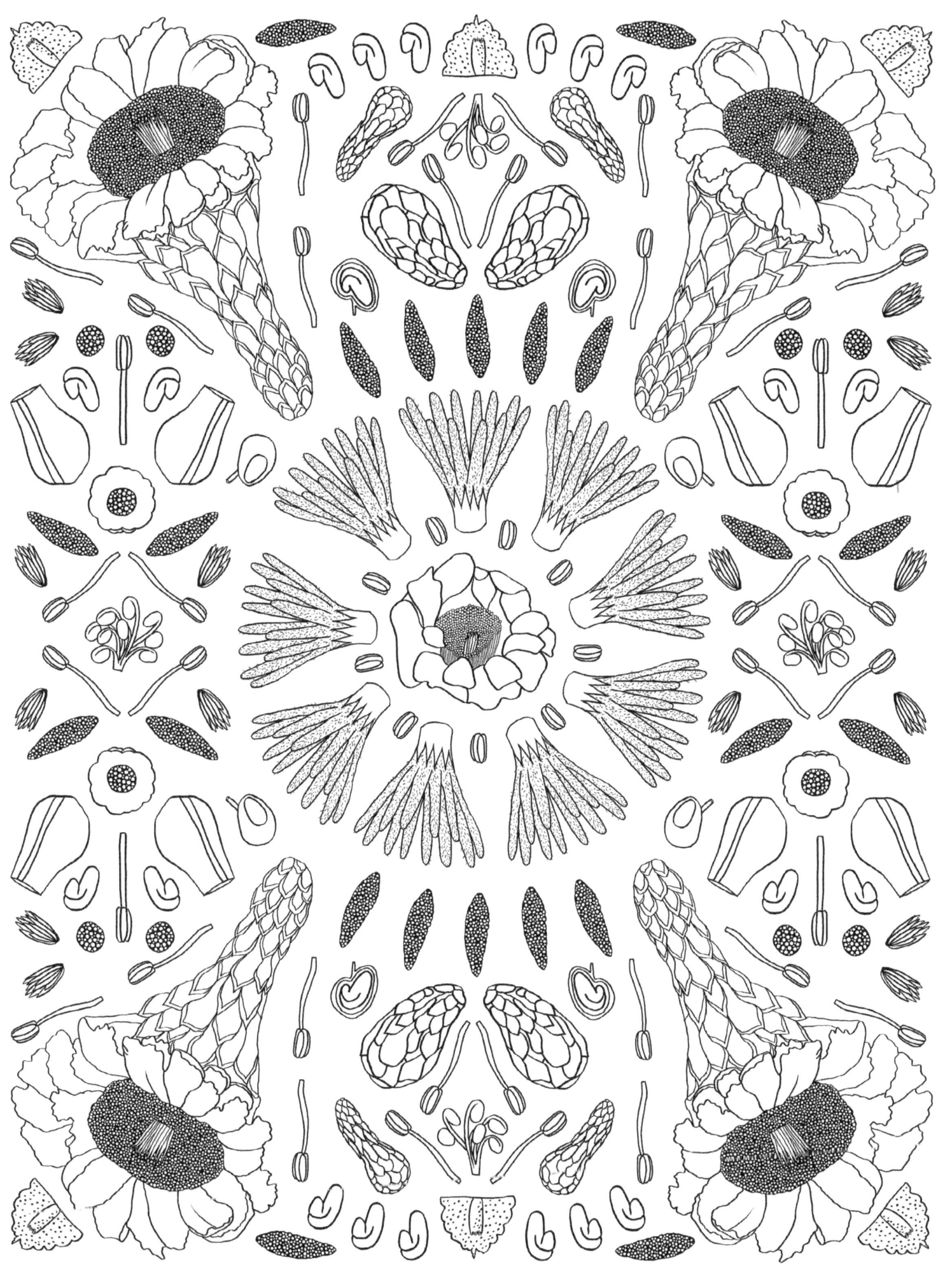

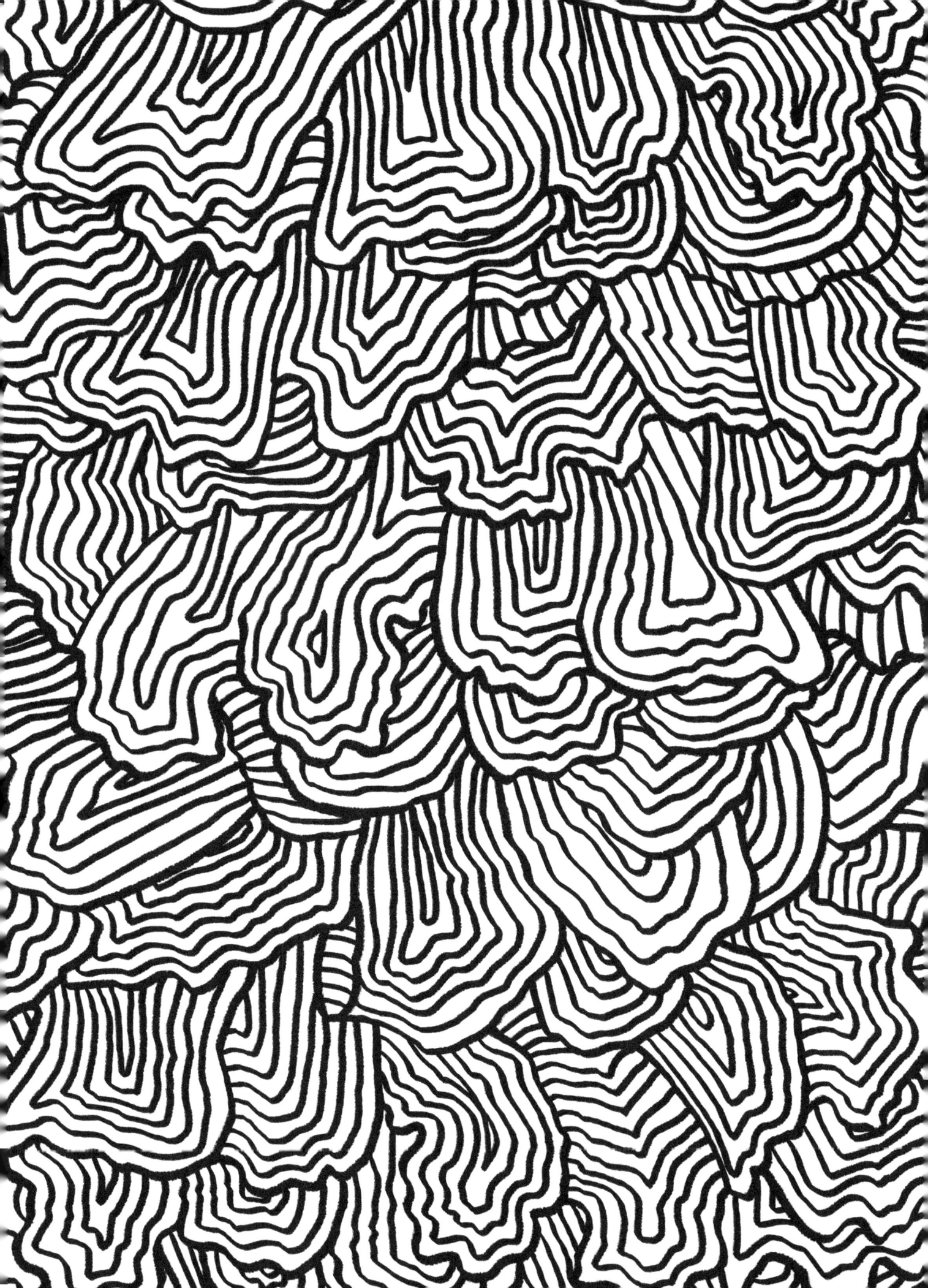

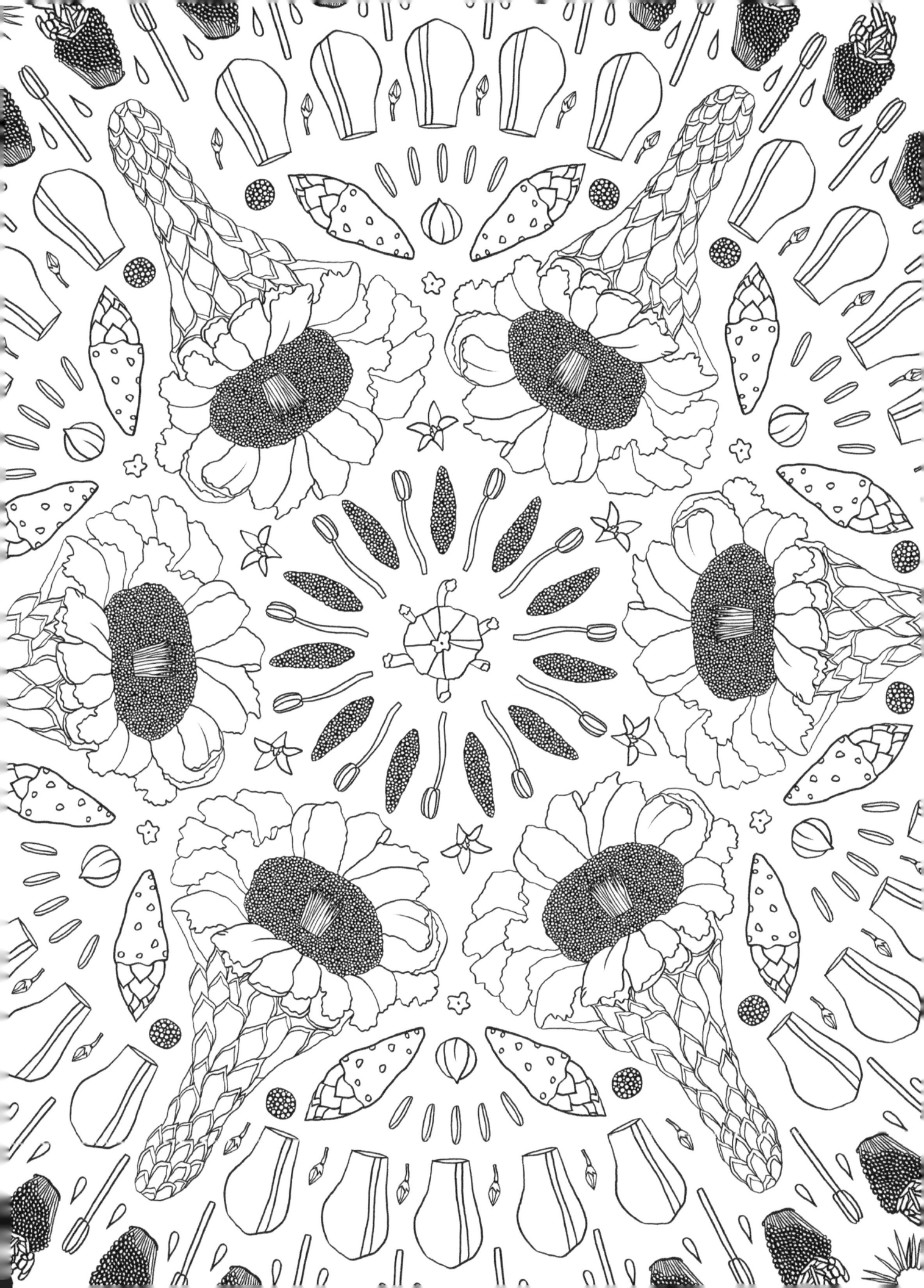

About the Author

Brittany Jepsen is the founder and creative director of the popular design lifestyle blog, The House That Lars Built, as well as a sought-after stylist, crafter, designer, and artist. On her blog and various social media platforms, she shares tutorials and advice on cultivating an artful life, in addition to offering licensed products with various companies. Her work has been featured in The New York Times, The Today Show, Vogue.co.uk, Le Monde, and CNN. She currently resides in Provo, Utah with her Danish husband, Paul.

WWW.THEHOUSETHATLARSBUILT.COM

Connect & Share

Connect and share your colored pages by using the hashtag #ColoringWithLars on your social media channels:

INSTAGRAM: instagram.com/houselarsbuilt @HouseLarsBuilt
FACEBOOK: http://facebook.com/TheHouseThatLarsBuilt/
TWITTER: http://twitter.com/HouseLarsBuilt
EMAIL: hello@TheHouseThatLarsBuilt.com

The designs and patterns in this book are for personal use only. If you are interested in licensing these or any other designs from The House That Lars Built for use on your products, please contact hello@thehousethatlarsbuilt.com.

www.ingramcontent.com/pod-product-compliance
Lightning Source LLC
Chambersburg PA
CBHW080618190526
45169CB00009B/3234